Little Windows into Art Therapy

of related interest

A Practical Art Therapy
Susan I. Buchalter
ISBN 978 1 84310 769 9

Principles and Practice of Expressive Arts Therapy
Toward a Therapeutic Aesthetics
Paolo J. Knill, Ellen G. Levine and Stephen K. Levine
ISBN 978 1 84310 039 3

The Artist as Therapist
Arthur Robbins
ISBN 978 1 85302 907 3

Art as Therapy
Collected Papers
Edith Kramer
Foreword by Lani Alaine Gerity
ISBN 978 1 85302 902 8

Therapeutic Art Directives and Resources
Activities and Initiatives for Individuals and Groups
Susan R. Makin
Commentry by Cathy Malchiodi
ISBN 978 1 85302 824 3

Little Windows into Art Therapy

Small Openings for Beginning Therapists

Deborah Schroder

Jessica Kingsley Publishers
London and Philadelphia

Cover artwork by Deborah Schroder

First published in 2005
by Jessica Kingsley Publishers
116 Pentonville Road
London N1 9JB, UK
and
400 Market Street, Suite 400
Philadelphia, PA 19106, USA
www.jkp.com

Library of Congress Cataloging in Publication Data
Schroder, Deborah, 1957-
 Little windows into art therapy : small openings for beginning therapists / Deborah Schroder.
 p. cm.
 Includes bibliographical references and index.
 ISBN 1-84310-778-3 (pbk.)
 1. Art therapy. I. Title.
 RC489.A7S367 2005
 616.89'1656—dc22

 2004020234

British Library Cataloguing in Publication Data
A CIP catalogue record for this book is available from the British Library

ISBN 978 1 84310 778 1

Printed in Great Britain

Contents

Acknowledgments

I feel fortunate for the presence of so many supportive and encouraging people in my life and I know that I can't name them all in this space. My parents, Frank and Cam Palicki, always supported my interest in art with art supplies and special classes. There are sisters, biological and not, and colleagues who have been tremendously supportive, including: Elizabeth Christenson, Mary Workman, Lisa Blocklinger, Penny Schwid, Susan Wasserman, Dawn Kohl, Jeff Knox, Judith Kalb and Kate Davis Rogers.

Thank you, Karen McCormick for your intuitive guidance and mentoring, particularly during the days when I was trying to figure out my identity as an art therapist.

I have been blessed with transformative places to work. Thank you, Mount Mary College and Southwestern College colleagues. Thank you, IFDS and HCT treatment team members.

My wonderful children, Jonathan, Joseph and Grace, have shown much patience with my work. Thank you. Muchas Gracias, Miguel Rodriguez for your sincere support of this book-writing process.

There are many incredible clients who have shared their journeys with me over the years. Their names and identifying circumstances have been changed in order to protect confidentiality. I feel tremendously honored to have witnessed small parts of those journeys. Thank you.

Introduction

I love to paint. I mostly use watercolor and acrylics but one summer I learned how to do silk painting and was astounded at the intensity of the color as it flowed through the silk.

My experience with silk painting has much in common with my thoughts on the use of directives in art therapy. I do wonder sometimes about the use of directives at all. That's kind of strange, I suppose, since this book contains many. I find great joy in making art without any preconceived ideas, and in encouraging others to simply create, using any art materials available. This kind of artmaking reminds me of watching the silk dye go where it will. Interesting colors and forms always show up.

I also find much meaning in making art with intention. Holding an intention or starting with an idea often provides a spark to creativity. Silk paintings can be given lines and structure by using some form of resist that holds the flood of color into desired shapes. The resist is something that the dye kind of bumps up against. In art therapy I think that it is often helpful for clients to have an idea to bump up against.

Either method of silk painting produces amazing images. I trust that any time, any way that people make art, amazing images will surface.

Part I

Getting to Know You

Beginning a Relationship Using Art

Do you remember the last time that you began a relationship? Not any particular kind of relationship, just a friendly exchange with someone you were likely to see again. Perhaps it was someone who moved into the apartment across the hall, or a new coworker, or the newest person behind the counter where you get your morning coffee. Chances are, the relationship didn't begin through artmaking. Although it's kind of fun to envision that possibility. Imagine two strangers exchanging small, hastily drawn images instead of doing the usual verbal exploration of "who I am". Think what this could do for the blind date experience!

But the reality of most of our lives involves a much more standard way of moving into relationship with one another. We place much emphasis on the verbal story, the words chosen, the grammar, accent, volume. We notice visual clues to identity through issues like age, gender, race, body language, personal space, clothing. If we're rather self-aware we may even attend to our own inner responses to this rich flood of information, and from that point begin making subtle interior decisions about moving ahead, or not, with the getting-to-know-you process.

It is extremely rare that two strangers would normally share artmaking or images with one another. In fact, family members and close friends aren't frequently aware of how each other draws or what kind of

art someone creates, unless perhaps one is a professional artist. Art therapists are a little unusual in that we may know how our best friend draws. Our best friend may be another art therapist or artist. When we ask people to make art as part of a new relationship, even though it is a therapeutic relationship, we need to remember what an unusual request we are making.

Before you initiate the getting-to-know-you phase of an art-filled relationship with a client, I want to suggest that you re-establish an art-filled relationship with yourself. Not that every art therapist wanders away from the studio, but sadly many of us give in to the other demands that seem to make the studio a distant dream or memory. Make the space and time to make art and try this directive: *Reflect on a time when someone else helped you, and create an image from or about that experience.*

We can't afford to stop looking at why we want to help and our beliefs about the helping process. After you create your image, work with it in whatever style is comfortable for you. If you like to ask questions, you might consider:

1. Who helped me? Did I want his or her help or did I simply need it?

2. What was my response? Did I resist or struggle or was I open to whatever help was offered?

3. How did I feel afterward?

I've done numerous images, over the years, about being helped, in order to center myself over and over again in terms of why I want to help and who I am as a helper. One of the most meaningful images for me was from a memory of a neighbor pulling me out of the mud when I was about 3 years old. I'd managed to get outside to play wearing my new shiny black shoes and while wandering around some trees at the edge of our yard, one foot became totally stuck in the mud. Some things that I remember about the experience include my fear of the helper (I didn't know the neighbor who pulled me out), my embarrassment at needing help, and my fear about what would happen when my parents found out. These fears seem similar to many client thoughts regarding entering therapy.

My experience with new clients, particularly those who haven't seen a therapist before, is that their anxieties and fears may almost completely muffle or distort how much they are able to hear or listen to in that first session. They may not take in most of what I say about myself, my way of working or the therapeutic process in general. They seem more worried about what they should say next, what they should or shouldn't reveal. They may even be trying to decide whether or not to stay in the room at all, as they nervously eye their watch or the door!

This is why I believe that in addition to the written intake and, if needed, a clinical assessment for safety, the first session needs to include an artmaking experience that is a mutual sharing of personal information. I know that there are therapists who would never consider this, but in the spirit of journeying with my client and initiating a safe, trusting relationship, I've found mutual artmaking to be very helpful. Cathy Moon discusses the fact that many art therapy graduate students are not exposed to the option of making art alongside their clients: "non-involvement in art making has historically been the more generally acceptable practice" (Moon 2002, p.200). My experience is that thoughtful artmaking alongside my clients is an excellent way of sharing myself in the development of the therapeutic relationship. It is, however, a form of disclosure, and mindfulness about the content of the images is important.

As always, when we decide to disclose any information about ourselves to our clients, we need to be very clear about what we share and why.

I remember the first time Megan came to see me. It wasn't an entirely voluntary experience. She was escorted by her mother who was afraid that her daughter was "slipping back" into behaviors that seemed to indicate depression. Megan was 16 and sat slumped in the corner of the couch, playing with the bracelets on her arm, while I went over the forms and confidentiality issues. When her mother left the room I suggested that it might be helpful if we just spent a little time getting to know each other better. I showed her the art materials and asked if she could create an image that would fill me in a little on who she was, while indicating that I'd do the same thing.

She seemed relieved and I put on some quiet music and we both began working. She quickly found magazine pictures to cut out, while I chose to work with oil pastels. Certainly I glanced at her as she worked, taking mental note of her comfort level and visible creative process, but I also created my own image that consisted of a few little drawings of visual information about me. I don't tailor that initial drawing to fit any perceptions about my client. Instead I just draw some things that are honest little scenes from my life at the moment. The image that I made during that session with Megan included a scene of a lake, a CD player, and a box with a big question mark on it.

When Megan and I shared our images she asked that I "go first" and I briefly told her how I'd spent some time over the weekend at a park by Lake Michigan and how calming it is for me to be by water. Looking at the CD player, I told her that one of my favorite things to do is to play my favorite CDs really loud, and that I'd bought a new CD on Saturday and had driven my kids crazy when I played it over and over. She looked a little surprised and said that she liked to play her music loud but that she used headphones so that nobody yelled at her. She asked me what the box with the question mark was about, and I told her that I'd recently moved into a new apartment and I'd lost the box that held most of my shoes. She glanced down at the rather sorry pair I had on and smiled.

I think that I probably seemed a little more human and approachable at that point. I'd shared honest little pieces of my life, but I'd certainly not shared others. In the process of looking for the box of shoes I'd had a full-blown moving day emotional meltdown, but that didn't feel appropriate to disclose!

When I do this initial sharing with smaller children, I might draw my pet, my favorite food, or some soft abstract swirls of a favorite color. I draw simple, clear images, and sometimes kids will sneak little glances at what I'm drawing and do the same kind of images on their papers. This is absolutely fine with me at this point. If it's comfortable for them to draw their pets, their pizzas and ice cream cones, and their favorite colors, I trust that we've laid the beginning of the foundation of safety with the art process and when the images that they really need to create emerge, our relationship will be able to contain them.

By sharing a little about who I am, with even my tiniest clients, the idea of talking to me and doing art while we're together seems more comfortable. The quirks and struggles of my images often open the door, allowing my tiny clients' own quirks and struggles to come in and be present. I tried to draw a rabbit hopping around the page once, because I'd had a day when I'd literally been all over the place. My rabbit looked more like a cat with goofy ears and little Beth almost fell off her chair laughing. But she also relaxed and quit saying that she couldn't draw. We welcome any image into the session, even confused rabbits.

I help adult clients welcome their own imagery into the room in much the same way. I utilize the same directive, asking that we create images that will help us get to know each other a little. I trust that whatever surfaces will aid us in the beginning of our journey together and will at the very least give my clients a taste of what art therapy feels like. Any image is welcome and the client is free to talk or respond as they like. We can put the image up and enjoy the colors or we can explore what the client sees within the content of the image. It is simply a small lived moment of artmaking and sharing, and it sets the tone for our work together.

I don't carry around any childhood memories of art as a "bad" or "difficult" thing because it seemed like the only thing that I knew how to do as a child. My experience is not the norm though, and it helps, as an art therapist, to deeply know the place of being asked to do something that at its essence may be linked to memories of feeling inadequate, embarrassed, or shamed. All that I have to do to be in that spot is to remember having to work math problems out on the blackboard in front of the class. From those horrible moments of feeling exposed and stupid, I developed the belief that I had best avoid any contact with math if at all possible.

So I speak very gently about the process of artmaking in art therapy with adults who have struggled with difficult memories or experiences of making art. While trying to calm any concerns about the quality of the art or the skill level of the client, I also try to share my belief that whatever image shows up is the image that needs to be there. For example, if I ask someone to create an image that tells me something

about who they are, and all that shows up on the paper is a big dark tornado, we'll certainly welcome the tornado and see what it's about: no rules, no wrong answers, no forbidden image.

We have a gift in art therapy that I don't think we always acknowledge. We have a clear, concrete way of demonstrating acceptance, by accepting the client's image. If I show you that I can sit with or be present to whatever shows up on the paper, chances are you will also understand that I can be present with your pain, you "ugly" memories, your scary dreams, your deepest fears.

Sometimes the situation of easing into artmaking is more complicated, particularly if the hesitant adult is part of a family art therapy session. Imagine the potential discomfort of being in a first-time therapy session with your spouse and children, only to find out that you are supposed to draw in front of the very people who you can hardly sit in the same room with. Parents often struggle with the idea of doing something with their children in the vulnerable space of the therapist's office that has the potential for making them feel even more vulnerable and exposed. The approach and tone that I take with families in that initial encounter is the same that I take with individual clients – let's use art to tell each other something about ourselves. Make an image that tells us all something of who you are.

The tension in the room almost immediately starts to decrease as family members learn that therapy can be simple and safe to experience. All that I've asked is to learn a little about everyone. We already know that there's a problem or they wouldn't be there. We've already even explored the problem a little, or the short version of the story, as we've completed the intake process. Stepping back a little and finding out through imagery "who's in the room" gives everyone a chance to just think about who they are, not who or what the problem is.

Beyond the warmth and openness of the sharing of our own images, and the acceptance of their images, how else can we help our clients know that therapy will be a safe place for them? I find it important to somehow communicate that I see or hear their good qualities, strengths, hopes. Someone in the therapeutic relationship needs to believe that movement toward health, self-fulfillment and/or happiness can happen,

and so I may need to share some of my optimism with them: not a false statement of "everything's going to be all right", but more of a belief that life can feel better:

> Communicating a belief and hope in the client's ability to change and an optimistic expectation that change will indeed occur is essential, especially in the beginning phases of treatment. (Asay and Lambert 1999, p.46)

How surprised some clients have been when we see "what's working" or what's going well in the image or hear it in their story. What relief to understand that therapy isn't going to feel like an agonizing scavenger hunt for pathology.

As the first session ends, I have the opportunity to let my client know that he or she is in charge of the artwork. It can be taken home or left with me. If it's a disturbing image I often offer to keep it safe, in my office. I am also pretty clear that "this is what it feels like" so that clients know that even though it was one pretty short experience of art therapy, whatever they experienced was valid. They can anticipate that the process will be pretty much the same next week.

I invite clients to come back with any art that they might create during the week. The work of therapy certainly isn't contained within the session. Perhaps I'll invite a client to keep a sort of feelings journal and create a few images of how they feel during the week. Sometimes, after an initial session with a tiny client, I'll send a little bag of small wooden clothespins home, and invite him or her to decorate a worry doll for every worry that they think about during the week, and then bring the dolls back in to show me at the next session.

The relationship has begun. Think of the strangeness or the miracle of two strangers sitting down for about an hour, making some art and somehow connecting through the images and stories that come with the images. The "journeying with" begins again.

The Path to the Issue
Working Toward a Plan

As I looked at my notes from my first session with Barbara I realized that I had only the most basic idea of when the numerous difficult events in her life of 52 years had happened. She had recounted so many sad occurrences, stressful issues and losses that I wasn't sure where to start. I trusted that deep inside she knew what work she wanted to explore with me, but on the surface the issues seemed very scattered. In an attempt to help us both see some order in her story I invited her to create a visual timeline.

I use visual timelines as a method of gathering more information in the interest of developing a holistic picture of what my client's life is like. Although a psycho-social intake form will certainly tell me the major dates and issues of a new client's life, it seems to imply that as the therapist I have the power to see the relationships between events or the ability to track the meaning behind patterns of behavior. I probably will have some ideas about how the puzzle pieces fit together, but I'm more interested in how my client understands and visualizes the flow of events, memories or years.

If I invite someone to create images of significant memories or incidents, both good and bad, the choice of what is significant is completely determined by the client. A timeline opens up our work together

to myriad memories. It allows strengths, successes and celebrations to surface, alongside the stormy years or volcanic events.

I would encourage any therapist to experience the creation of his or her own timeline before asking a client to create one. There are two different ways that I like to work with timelines (Figure 2.1):

1. Start with a long strip of paper from a roll of paper, perhaps twelve inches wide and three or four feet long. Draw a line down the middle of the paper, lengthwise. Choose a starting date and create an image there that indicates what point in life you're starting from. Many people choose their birthday, but there's no "wrong date" to start from. Continue creating whatever images you like, along the timeline. Try to stay in the order that the events or experiences occurred. When you're done you might want to title and date each image.

2. Create images of important or significant events, memories or sections of time. When finished, attach the images to a long piece of paper, in the order in which they occurred. You may want to title and date the images.

When people create their timelines they usually don't need much encouragement to talk about or explain the imagery that has appeared. Sometimes the images are very specific, perhaps a baby to indicate the birth of a child or a raggedly torn heart to show the demise of an important relationship. Other timelines are more abstract in nature, with colors, lines and shapes telling the story.

Sometimes people are surprised by the sheer number of difficult or stressful events that took place within a certain period of time. Sometimes just the acknowledgment that life has indeed been tough lowers a person's hesitancy about the need for help or therapy. People say things like "No wonder I've been feeling stressed out".

Some timelines are pleasantly surprising because of the good relationships, the good years, and the happy moments that become visible. I see sources of support and strength that I might not have heard about through verbal questions.

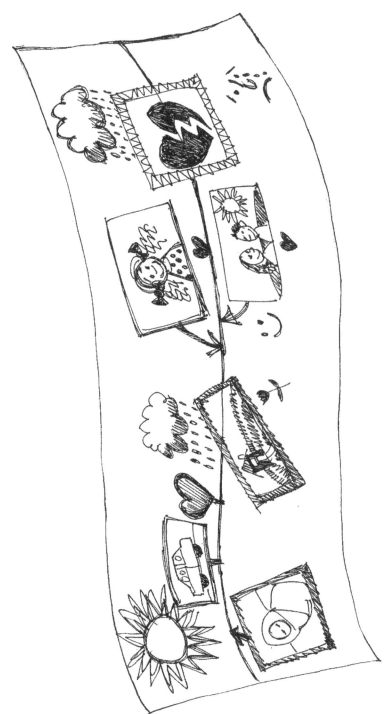

Figure 2.1 Timeline

When a person includes numerous events and memories, we often explore the timeline over several sessions. If the timeline is particularly sad or somewhat troubling to view in its entirety, we look together at manageable chunks, and the client determines which pieces to talk about.

One of my favorite uses of timelines is in family therapy. Each family member brings his or her own unique understanding of family life to therapy. The timeline enables each person's understandings and memories to become visible. I use the same art processes, asking that all family members contribute to the same timeline. As with many other family art directives, it's certainly interesting to watch how the members interact, who takes charge, who hesitates. In her book about family art therapy, Shirley Riley speaks about the value of watching family members as they engage in some sort of shared drawing task (Riley 1994). By watching family members make art we get an interesting view into how they organize themselves, how they share materials and solve problems.

It usually becomes clear very quickly that we have a variety of visual interpretations of family history within the images. Children and adults often have very different ideas about what was important or significant in the family's history. Sometimes the adults may be the ones who think of the special or good times. Frequently, the children will draw in with enthusiasm huge images of a family vacation or a significant holiday.

At times, a stressful or unhappy event that to a parent seemed trivial and perhaps not worth mentioning will take up much space when illustrated on the timeline by a child. This is an important opportunity to explore the differences in emotional impact upon family members of that event.

Fourteen-year-old Robert watched with interest as his mother drew an image of a school. She talked as she worked about how proud she was of Robert's elementary school years. He waited until she was finished, and then colored in stormy gray skies all around her picture of the school. She clearly didn't understand what he was doing and when she asked him about it he told her about his memories of being in that

school. He remembered worrying all the time about making friends and felt that those years had been filled with loneliness.

Robert and his mother and stepfather had entered therapy because of some recent behavioral issues that involved Robert's current friends. As he became a little teary talking about his grade school years, his mother's face visibly softened toward him. We all witnessed evidence of love and empathy in a family that, by their own report, hadn't sounded loving toward one another in some time.

Whether I'm working with individuals or families, I believe that the timeline helps us move in the direction of a plan for our work together. I'm particularly interested in how people envision the next phase or "future" section of their timeline, and often ask them to take it home with them to think about and add images to. I like to encourage them to create images of what they'd like life to look like, what they'd like to see happen. There are no rules about what images should or shouldn't appear in the "future" section of the timeline. Multiple versions of future possibilities are helpful. What colorful possibilities are often envisioned. How telling it is, however, when no positive images of the future are visualized. The blank space, instead of being open to possibilities seems sadly barren. The room grows terribly quiet.

When my client Barbara decided to come to therapy, she felt overwhelmed by life's issues and she couldn't imagine any pictures of what her future might be. When we looked together at her timeline she commented on how cluttered the past few years looked from a purely visual perspective. We talked about how it might be more visually appealing and she decided that making some simple choices about what she wanted to see in the image might also encourage her to make some choices about where our work together might take her.

When Robert and his mother and stepfather came to the "future" section of their timeline, they had no conclusive ideas about what their future should look like, but they did know what they didn't want to see. They all agreed that they didn't ever want to have any more angry explosions that might lead to the need to call the police. And so we had a beginning, a piece of the road map for our work together.

Another experiential activity that I like to use in this beginning stage with families is the "kingdom" exercise, loosely based on Liebmann's "Own Territories" art experience (Liebmann 1986). I pull a long sheet of paper off a roll, long enough to cover the length of the table. I use a black marker to divide it up in sections, one section for each family member. Then I tell the family that each person has their own kingdom and can draw anything in it that he or she wants. I have a variety of drawing materials available for them. When it appears that everyone is finished with their images, I tell them that they have a few minutes left and that they can decide if they want to create any connections between the kingdoms. The results of this art experience are usually so revealing to me and to the family that I find myself asking almost every family that I see to do it.

Over the years I've seen a fascinating variety of fortresses appear within the borders of the kingdoms. In one family with three boys, the images were particularly dramatic. Two of the boys, who happened to be sitting by each other, created massive defensive structures and completely reinforced the boundary between each other's plot of land. Huge stone walls on one side had barbed wire entwined around the top. On the other side of the wall, mean-looking guards stood ready with guns pointed at the border. One brother created a concrete castle complete with a dragon-filled moat. On the other side of the table, the mother created an idyllic scene of a small cabin surrounded by green grass, flowers and animals playing happily in the sunshine. Next to her sat her husband who drew himself in a boat in the middle of a lake. Next to him around the table sat the youngest boy who created a colorful video arcade with many paths and roads going in and out so that his family could visit. When I mentioned that the family could choose whether or not to connect with each other, this smallest boy was the only one who added more access.

The kingdom images were rich with much valuable information. The obvious use of this experiential is certainly to look at boundaries within the family. I'm always interested in who in a family fortifies boundaries, who ignores them and draws on another family member's space, and

who chooses to try and negotiate passageways or shared space. With this particular family, I was concerned about the intense fortification between two of the brothers' kingdoms, and asked some questions, which did lead me to have concerns about safety in the home at night. Some other issues that arose from this image included the youngest child's attempts to connect with family members, the father's complete inaccessibility, and the mother's withdrawal behind of façade of "everything's fine". Except for the youngest boy, no one in this family had expressed an interest visually or verbally in interacting together. We had much from this session that we could talk about as we began to formulate a plan for our work together.

This initial attempt at creating a plan sometimes feels premature at this early stage in therapy. How quickly one needs to develop a plan is often largely determined by external factors, including agency policies, accreditation guidelines and insurance companies. Clients themselves, though, are also often concerned for a variety of reasons, about "how long this will take". While I don't like to make predictions about numbers of sessions, I do understand their concern and find it an opportunity to talk about and to figure out how we'll know when we've finished our work together. Again, we can revisit the image and ask, "What could life look like? What might it look like when we've done our work?"

I supervised two in-home treatment teams for several years and learned a lot about helping clients participate in treatment planning from the therapists on those teams. Most of the therapists came from a background in social work and one of the many strengths of that perspective seems to be the ability to be very clear verbally about what needs to happen within the framework of treatment. One of the routine questions used by the treatment teams was the "magic wand" question. There are different versions of this question, and it has been credited to a variety of sources (Homrich and Horne 2000). Sometimes it sounds like this: "If I had a magic wand that could take away problems, what would your life look like?"

My art therapy version of that question is the "crystal ball" directive. In this beginning phase of art therapy I'm still very concerned about

helping the artmaking process feel comfortable. I appreciate the safety and containment of using a circle to hold images, and so I draw a large circle on a piece of paper, and then make it appear to be resting on a holder, like a crystal ball (Figure 2.2). I encourage clients to use whatever drawing materials they prefer to create an image of what they'd like life to look like.

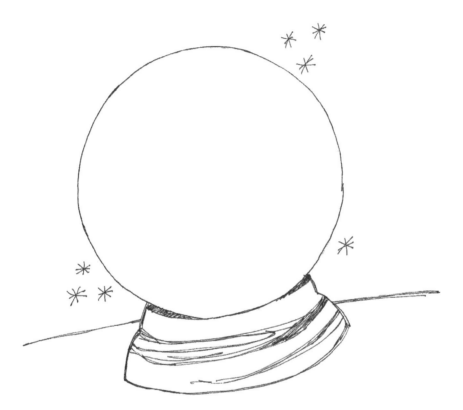

Figure 2.2 Crystal ball

When 16-year-old Megan created an image of flowers and swirls of bright colors inside her crystal ball, she told me that she just wanted to feel happy. I asked her how we'd know that she was happy and she made a sarcastic face at the silliness of my question. But I asked again, "No,

really, how would I know that you were happy?" She came up with a list which included crying less, playing volleyball again and going to the mall with her friends. She clearly knew what the soft hopefulness expressed in her colorful crystal ball really meant. She was the only one who could determine what "happy" might someday look like for her.

With the art product we have the opportunity to visualize and look at the "what ifs". What if I made peace with my sister or took a night class or was able to drive across a bridge again?

When I'm getting to know younger clients I sometimes ask them to literally "try on" something that they're hoping for. Little Carrie couldn't remember when her tummy didn't feel tied up in knots. So I invited her to use her imagination and decorate a paper vest cut from a brown paper bag (Terzian 1993) with art that would show what she'd do if she wasn't feeling worried (Figure 2.3).

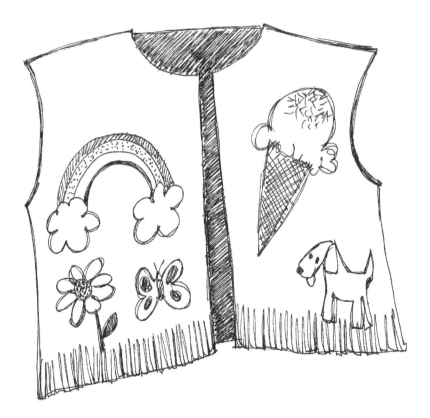

Figure 2.3 Paper vest

Carrie decorated her vest with bright sequins, buttons and pictures of kids having fun together at the park. She immediately tried her vest on and we found a mirror in the restroom so she could see how she looked in her creation. Then she flew into the waiting room and pirouetted in front of her surprised mother.

When she talked about her vest it was very clear that she had been able to experientially "try on" a feeling of lightness. We had lots of good information from this art piece. We talked about where in her body she had experienced the lightness or happiness. Over the next few months we worked hard to figure out what parts of life created lightness and what parts of life tied her up in knots.

Decorating a vest has also been a useful directive when I just want to help a younger client enjoy showing me something about himself/herself in a more playful way. If my young client and her parent and I have spent too much time talking and filling out forms during an initial session, I might send a paper vest home with the child, inviting her to bring it back next week decorated in a way that would tell me something about her. Six-year-old Andy brought his back covered with candy wrappers and pictures cut out of magazines of skateboarders. Andy didn't know how to skateboard but he missed his older brother who was placed in a different foster home. And he certainly thought that it might be helpful to make it clear to me what his favorite candy was! Between the wrappers and the magazine pictures I had a tiny window into who my new client was.

Getting to Know the Reluctant Client

I've been the reluctant client. Certainly on a scale of one to ten, with one being low, I was about a two. But I know that place of hesitancy to be in therapy from a very personal understanding. Unconsciously I was afraid of where the therapy path would take me because I knew, deep down, that I was walking on the edge of initiating tremendous change. What Susan did for me during that first session was to allow the space for me to say that I wasn't sure that I needed to be there, *except*: except that I was contemplating a divorce, I had three kids and three jobs, I couldn't sleep and I found myself crying every time I was alone in my car.

Helping me come to terms with the fact that it probably was okay for me to spend an hour for myself each week in therapy was the key to helping me move through my reluctance to be there. Other clients can be much more reluctant to engage in the therapeutic process. I've encountered three main types of reluctance in my work with clients.

The first include those who are reluctant because of inner knowledge about the hard work to be done in therapy or because of where they suspect the therapeutic path may lead. This client knows the potential cost of doing the work, and has good reasons for hesitancy: "Perhaps if I don't really look at this issue it will go away." Sometimes the

client's physical body insists that it's time for facing the issue by developing such concerns as headaches, panic attacks, digestive problems, sexual dysfunction or insomnia.

So the person has decided to come to therapy but even while sitting in the room with the therapist is hatching an "escape plan" in case he or she decides not to do this. The dilemma for the therapist seems to be somehow getting to know the client while holding open the space for the client's ambivalence. There is an art therapy directive that works well in this moment.

I give the client a sheet of white paper that already has a mandala or circle (about the size of a dinner plate) drawn on it. Then I offer a variety of pencils, pastels and markers and ask the client to "Draw whatever was going on inside your head this week, inside the circle, and whatever was going on around you, at work or school or home, outside the circle." This is one of my favorite art directives to do for myself, especially when I find myself overanalyzing or staying in my head with an issue. The circle provides containment and the image literally shows what is going on inside and gives me the opportunity to connect with whatever feelings are attached to those that thought made visible.

Sometimes my client will fill the image, inside and outside, with words. Diane, a businesswoman and mother of two small children, first used colored pencils to fill in her circle with words about things she needed to do and places she needed to be. Then she added more words around the outside of the circle, about more responsibilities. Some of the words started crossing the boundary of the circle and she seemed a little edgy when she looked up and said, "I guess I have a lot going on." I quietly said, "It looks like you've had a lot going on for you this week." She took a soft pastel and smeared it over the circle and started crying. She was able to stay with therapy because she had connected to the immediacy of what life felt like in that present moment, through the art.

Some interesting things to look at with this art experience include the following.

- *The boundary of the circle*: is it preserved or do images/issues cross over from one direction to another? Has the client reinforced the boundary or the actual line of the circle?

- *Colors used, line quality, and content*: what is present and how was it drawn?

- *Placement*: what takes up the most space, what is in the center? Does the client divide the circle with lines in order to compartmentalize or encapsulate issues?

- *How does the client react to this image*: does the client have much to say? Does the client seem eager to explore all that's going on in the image or does the client just want to sit with it or perhaps put it aside quickly?

As we witness whatever images or words emerge in and around the mandala, I have the opportunity to hear my client's thoughts about continuing the therapeutic journey. The client often looks at the image and makes choices about what issues to prioritize. The client has a chance to tell herself and me how hard it is to walk around with that thunderstorm inside, and that perhaps it is time to deal with it.

The second type of reluctant client is the one who is there because therapy was someone else's idea. I have much empathy for this client. Imagine being "brought in" by a spouse or parent. No matter how well intentioned the other person is, someone else's concern has still landed the client in a place where he or she doesn't want to be.

The situation that seems to arise most frequently is the child or adolescent who has been brought in unwillingly. Sometimes they've even been threatened with therapy in a misguided effort to get them to "shape up". You can imagine the level of cooperation in the room!

When the parent finally leaves the room, if my client is a child I might just offer the art supplies right away and say, "Want to make some art?" If my young client says no or sits silently, then I go ahead and make some art. And almost always my client's curiosity is aroused, by the strange thing I'm drawing, or the fact that I ask for an opinion on color or what to draw next, or maybe by the mess I've made with the clay. I

make it pretty clear that I love making art, I'm okay with anything that shows up in the art, and that this whole horrible therapy thing could *almost* be fun.

Virginia Satir was known for her belief in sharing one's humanness in the therapeutic relationship (Satir and Baldwin 1983). This kind of relational risk taking seems particularly important when inviting a reluctant participant into the therapeutic process. Cutting through any pretentiousness or platitudes and moving to the reality of "you and me stuck right now in this room together" has been helpful for me to articulate at times.

If my reluctant client is an adolescent I often offer the honest observation that "It kind of sucks having to be here, doesn't it?" The client and I have certainly heard from the parent(s) why the client is here, but I'm really interested in the client's understanding of why he or she is here. Sometimes my reluctant client will say "Because that bitch brought me!" I can only empathize with "Sounds like life is kind of tough right now," and I get out the art materials. It may turn out that during that session I'm the only one playing with the pastels, but often, just to have something to do with her hands while quieting her inner anxiety, my client will engage with the art materials too.

The third kind of reluctant client has been court ordered to participate in therapy. Some of the favorite families I've worked with have started out as completely involuntary clients. In almost every case these families had much at stake with their participation, often the ability to keep one of their children in their home. The stakes were high and participating in family therapy was a sort of last resort, after many other options had already been tried. The families were tired of talking, tired of professionals involved in their lives.

Offering art and shifting the therapeutic process from talking about the problem to experientially exploring family dynamics was powerful. But most of these families were cautious about making art together for good reason. At this point in family life they often couldn't even eat dinner together, let alone do something with a playful component in it. They hadn't played together in a long time. This is why I like to ask

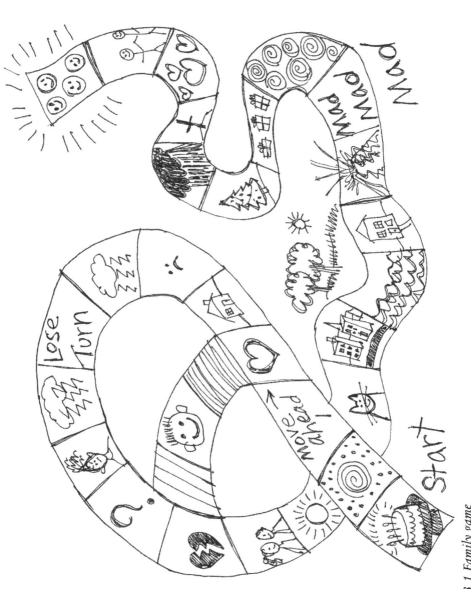

Figure 3.1 Family game

reluctant clients, especially families, to create a family game (Figure 3.1). I give them a blank game board with a beginning and an end, and plenty of twists and turns, and ask them to fill in the squares with images and directions. The images in and around the game need to have something to do with the family's life and history. Other than that there are no rules. I encourage therapists to make a game board for themselves before asking clients to do this. What good moments have enabled you to "move ahead one space"? Was there a difficult year when you lost momentum? What does the end of the game look like? What would signify success?

We play the game together during the next session. Symbols are created by each member in order to move around the board, a process that can be enlightening in itself. The dice is thrown and someone moves ahead, needing to talk about whatever square is landed upon. Sometimes another family member needs to supply details about a square of family life that he/she illustrated. Little by little we ease into relationship with one another.

It probably sounds a little goofy, but I'd rather sit down with a whole family of court-ordered, reluctant clients, than just one court-ordered, reluctant client. Within a whole family, I've found that there is a good chance that someone in the room is quite concerned about the wellbeing of someone else in the family. There is often the sense that "I'm not doing this for me, but I might cooperate to get Jim some help". The feeling in the room is a little different when the only people present are an adult client who has literally been ordered to be there, and me. In those moments, I've found that a heartfelt talk about the choice to participate in therapy may be helpful. I try to be honestly empathetic to their situation, while helping them to see my responsibility in the context of their participation. I encourage them to choose to participate with an attitude of openness to the possibility that it might actually be helpful in some small way, and I also state that someone will be asking me to confirm or deny their participation in therapy and that I will be honest in my response. I also am very clear and careful in my explanation of client

confidentiality. I always approach these reluctant clients with the same respect and concern that I would have for any client.

In terms of artmaking, a helpful experience is the inside/outside box. This is one of those directives that is used so frequently and has been changed and adapted to so many situations that I truly don't know who developed it in the first place. I do know that it remains a powerful, meaningful process for clients, reluctant or not. I give my client a small box with a lid, and ask him or her to put images on the outside of the box that represent what they show to others. I ask my client to put images on the inside of the box that reflect who they are and what they feel, images about themselves that they may not share with others. I stress that they don't ever have to open the box for me. It is completely their choice about what they share in therapy. This process helps clients know in an experiential way that they have power and choice in this relationship. The idea of having even some small degree of power and choice may be particularly important to a reluctant client.

When I describe clients who are reluctant, I purposely avoid using the term "resistant". This word carries much power within the mental health community and often has a negative connotation. I don't view true resistance as anything negative. I agree with Bohart and Tallman in their assessment of resistance as a multidimensional concept. They speak of the "implicit proactivity in most cases of resistance" (Bohart and Tallman 1999, p.260). They believe that clients try to solve problems from their own point of view or from their own understanding of the problem, and that there are numerous reasons why looking to someone else for a solution may threaten a whole range of connections, relation-ships and understandings about their personal world (Bohart and Tallman 1999).

Resistance usually seems to me to be a logical response on the part of the client. I trust that my reluctant client has developed a method of moving or stepping back from the therapeutic process in a way that has become a useful response; a response that serves a purpose within the therapeutic process and can be honored by the therapist, if the therapist can be honest about his or her agenda and expectations.

When I am honest about my own fears around knowing enough, being enough or having answers, I seem to be more present to the knowledge that my clients already have; knowledge about issues and relationships that they may be reluctant to share but that does emerge inside mandalas or through a 10-year-old's story about the happy-face-move-ahead-two-spaces square on the family game.

CHAPTER 4

Welcome to the Living Room

I could hear Maria yelling at her brother before the door opened. When she did open the door she looked like a little angel, smiling sweetly while motioning me inside. "Tiny, stay down!" Tiny, who was anything but tiny nuzzled me with his big, furry, drooling face, barked what might have been a greeting and lay down directly in my path. I managed to make my way over to the couch, cleared off a few toys and sat down. Maria's mom and brother came in arguing about whose turn it was to do the dishes and a small neighbor boy darted upstairs, which triggered much thunderous barking from Tiny. Never in my wildest dreams had I imagined doing therapy this way.

In-home therapy is a way of working, however, that seems to be growing in popularity in many communities. Nonprofit agencies, county health and human services departments and treatment providers who do work in the area of family preservation all seem very interested in encouraging the delivery of mental health services literally to the doorstep. There are certainly some compelling reasons why. When I'm doing family therapy I am especially interested in doing whatever I can in order to facilitate all family members' participation. There are so many barriers to participation within families, including lack of transportation, an inability to afford childcare for babies or toddlers, health issues or disabilities that make it difficult to leave home, and nearly impossible family schedules. There are areas in some communities where there are no convenient mental health care providers and clients would

have to travel to outlaying suburbs or communities in order to access therapy. There are parents who simply will not put forth the effort to make certain that their child sees a therapist. There are situations when it's helpful to have a therapist see the home environment firsthand. There is a wide variety of reasons for why a therapist might find him/herself spending an hour a week in someone's living room doing therapy.

Even though in-home therapy is convenient for the client(s), we can't assume that it is always desired. When in-home therapy is involuntary, families may feel that it is intrusive. The therapist may be just one more "outsider" perceived as snooping in the family's business. Sensitivity to the family's comfort level will be terribly important. An in-home therapist still has the responsibility to welcome and ease his or her client(s) into the therapeutic relationship. But this is all taking place in the client's territory so any control that one likes to feel one has over the therapeutic environment has pretty much flown out the window. Suddenly you are both guest and therapist. This can be a delicate dance.

I learned by trial and error that I needed to be assertive about some of the logistical details of how we do the work. I was very clear about sticking to the designated appointment time whether dishes or homework were finished or not. In return I was very conscientious about leaving on time. No friends were allowed within earshot and there couldn't be any talking on the phone. The television had to be off (this was a huge issue in some households). There couldn't be any smoking, which was hard to insist on in someone else's home but my lungs just couldn't take it. People needed to be dressed appropriately; no jammies unless the family member was under three!

My other rules were largely unspoken, and were mostly just personal preferences. I would hold cats, small dogs and babies, but I wouldn't touch pet snakes, rodents, lizards or iguanas – especially iguanas. I would visit bedrooms to view special toys or collections but the door had to stay open. I would encourage people to call me and cancel if someone in the home was sick.

One of the issues to be conscious about is the question of how and where to create art in someone's home. I found it important to be very sensitive to my client's needs and I tried to bring fairly unmessy materials such as washable markers, crayons and colored pencils. Dining room tables and coffee tables worked pretty well, but I found it helpful to bring along a plastic tablecloth to protect the surface of whatever we worked on. The days when I did a lot of in-home work meant that the trunk of my car became a sort of traveling art supply closet. (Never leave oil pastels in the trunk in the summer!) I also knew the location of every relatively clean restroom in the metropolitan area.

Given all the complications, one might wonder what are the benefits to in-home work. The biggest benefit, without a doubt, is the amazing opportunity to see a little view into what family life is truly like. Sometimes when I've sat in the middle of the chaos and heard the yelling firsthand, I have gained enormous respect for my clients' struggles. Other times I have had the privilege of witnessing a tender moment between parent and child, or between siblings, and I am reminded of the love underneath the current crisis. I got to spend time with grandma, admire the tomato plants, shoot hoops while we waited for dad to get home, and smell dinner cooking. I got a feel for what it was like to live in that place.

This different kind of therapeutic relationship tests many therapists' preconceived ideas about boundaries. The involvement with the family is at once intimate and professional. The intimacy develops more quickly than it does in the office because we are privy to so much more personal information. Even the art experiences often take on a deeper sense of poignancy when the art is created around the family table. The family's timeline, full of significant images, becomes even more meaningful in the presence of wedding photos and baby pictures, hanging on the wall over the table. The image drawn of a trip to Disney World may be supplemented with a photo album or even a video from the trip.

The artwork and the conversation became a little difficult to keep confidential if I was seeing only one member of the family. It could be hard to find a place to work if I was there to see only one of the children

and everyone else was home. We needed some privacy and sometimes that can be very scarce in a big family. There might also be confidentiality issues within the neighborhood, and when I was asked who I was by a neighbor I always said that I was just a friend.

Sometimes I felt a little bit like a friend. I saw one of the mothers in a family that our treatment team was involved with every Monday morning because that was her day off. Sitting on her front porch drinking coffee on those summer mornings was a delightful way to do therapy. She was warm and funny and I have no doubt that we could have been friends if the situation had been different. It was up to me to make sure that the relationship was completely centered on therapy.

Feeling centered at all could be a challenge with in-home therapy. The same opening into clients' lives that was so helpful could also be stressful and at times I longed for the organization, quiet, and order of the office. It is important to stay mindful of safety issues. There are no colleagues down the hall with in-home work, unless you are fortunate enough to be doing co-therapy. Letting colleagues know where you are and carrying a cell phone are important safety factors. If your intuition tells you that something doesn't feel right, it's important to honor that feeling and leave. In one neighborhood, people thought that I was going to a particular home to buy cocaine. The harassment by the neighbors and the probability that someone in the home was dealing made the situation feel too unsafe.

For the most part, in-home work was meaningful and productive. There were some wonderful moments when a family would be gathered in the kitchen making art together and I felt like the luckiest therapist on the planet to be able to witness those warm, playful interactions.

Part II

Deepening the Relationship

Moving into Deeper Work

Barbara's eyes looked red and teary when she entered the room. Before I could say anything she asked me if we could take another look at her timeline. When I pulled it out and opened it up, we both sat quietly, letting the visual impact and impressions that the images aroused revisit us again. Her voice caught in her throat a little as she said, "work problems" and pointed to an image on the timeline representing a difficult year in her mid-twenties. The image was of two tigers eyeing each other nervously, poised for battle. It reflected a time when Barbara and her older sister both worked in the office at her family's business and were literally at each other's throats most of the time.

Barbara touched the image as though she was smoothing the tigers' fur, a quieting, calming gesture. I asked her if she could create another image in response to the tiger image and she nodded and found paper and oil pastels. The image that emerged was a huge, snarling tiger that almost filled the entire page. When she finished the image she allowed herself a small smile and said, "This is me at work." A new coworker had triggered fierce feelings of competition and she felt scared and envious, much as she had when she and her older sister had shared an office many years ago. We used both tiger images in our work together to begin exploring in depth her buried feelings of inadequacy and shame.

Barbara had reminded me of the good work that can happen when we revisit the timeline and choose an image to amplify, alter or respond to. The timeline seems to function much like an old neighborhood in its

familiarity. We can wander along, pause and linger anywhere that interests us. Our visit can be short or long, depending on our client's needs and memories. Barbara instinctively knew that the roots of her current pain originated back in a difficult relationship with her sister.

The exploration of relationships often moves the therapeutic relationship into a deeper place. Sharing words or images about family members, in particular, requires a level of trust in the therapist and the nature and path of the therapeutic work. Sharing significant memories from one's family of origin or current family relationships often requires that a client break an important family rule about "not telling our family's business" or "what goes on in this house stays in this house".

When I was little one of the big rules during swimming lessons at the local YWCA was "Don't go in the deep end". Since I was pretty afraid of the water anyway, this was an easy rule to keep. Suddenly one Saturday morning the instructor told us to grab our little float-boards and paddle to the deep end. I completely froze.

Clients have their own good reasons for "freezing up" when asked to remember powerful relationships. An art directive that I like to use involves making this remembering feel safer and more contained by using a quilting image for the work. I give the client a stack of a variety of colors and textures of paper, cut into 5-inch by 5-inch squares. I ask that he or she use as many squares as needed in order to create a quilt made up of important people in his or her life, decorating and creating images on the squares that symbolize these important people (Figure 5.1).

Particularly during the days of slavery in the United States, piecing together bits of fabric from family members' clothing became an important way to tell the family's story and make a warm blanket. A piece of grandmother's apron, a square from uncle's overalls, could be sewn together to create a valuable family history during a time when families were being ripped apart at whim.

Faith Ringgold is an African American artist who has used quiltmaking and quilt imagery extensively in her work. Her images may be helpful to refer to when exploring the use of quiltmaking as storytelling (Ringgold, Freeman and Roucher 1996).

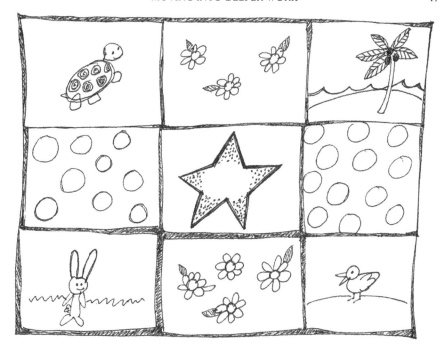

Figure 5.1 Important people quilt

When I ask people to create small images representing people in their lives, I'm interested in noticing which images are created first, my client's affect while creating the images, and how the little squares are placed together in one larger quilt image.

There are no rules about these important people quilts. No certain number of people needs to be represented. I've seen a very beautiful, meaningful quilt made up of two squares, each representing a treasured grandmother. I've also seen a quilt made up of 20 different little squares, each one filled with symbols and colors bringing a large group of close, supportive friends together in one art piece.

When we talk about whoever is present in the quilt, the client chooses who and how much is shared. Most quilts, just like true family heirloom quilts, contain a poignant mixture of sadness, longing, strengths and support. There is a mixture of memories just as there is a mix of textures, patterns and colors.

As with the timeline, the quilt's creator has the opportunity to choose a particular image from the quilt and focus on it by creating a larger image or by exploring that person or relationship in depth, verbally. We can also expand on the quilt and create an image-filled genogram. Some clients bring issues to therapy that are connected through the generations to myriad family ancestors and patterns (McGoldrick and Gerson 1985). Perhaps a significant aunt will appear in a quilt and as my client talks about her I hear a story that seems connected to many other relatives and their way of life. A genogram will allow us to see the connections, patterns and relationships (Figure 5.2). A genogram created with color and symbols, yarn and stones, paint and glitter, breathes another layer of life and meaning into the process.

Figure 5.2 Genogram

Certainly genograms have long been an accepted part of family therapy work. When we add art to the process we bring family members' feelings, symbols, personalities and visual interpretations to the historical family map. Stories about strengths, characteristics and family traits are usually abundant. I asked 11-year-old Mike to create an image to represent his grandfather. Mike explained that he'd never met him and so he couldn't make any art about him. It became an opportunity for Charlie, Mike's father, to tell Mike about Grandpa Peter's funny laugh, droopy mustache and quick temper. Mike created a funny little ferocious-looking dog with droopy ears, which became the representation of Grandpa Peter on the genogram. While Charlie laughed at the fierceness of the little dog's expression, he also acknowledged that his temper could be a little like his father's and he was able to ask Mike if he was ever afraid of him.

When people are able to begin sharing their fears, verbally or visually, I know that we may be moving into more difficult work for the client. There are risks inherent in bringing fears out into the open, out into the light and air. One way to gently invite any present emotion to surface is to invite the client to create a current emotional landscape. Using any media I ask clients to create a landscape that will show what life feels like right now. With some of my clients I need to talk a little about landscapes, but most have known that it's just a picture of an outdoor place. What would you be if you were an outdoor place today?

What *would* you be? This is another art experience that is important to try before asking someone else to do it. This is also a good way to center oneself after a session, especially a difficult one. If my emotional landscape is a dried up sandy lakebed strewn with fish gasping for oxygen, I probably need to ask myself why I feel so depleted after spending time with that particular client.

Patrick, who was 42 and going through a difficult divorce, created an image with colored pencils of a bleak-looking rock wall with several caves. My own inner reaction to the image was that it felt empty and rather cold, and I was concerned about the unwelcoming caves. Patrick described the image, however, as a place of needed solitude after a

stormy break-up. He talked about feeling satisfied with his aloneness and solid in his stance about ending the relationship. The caves were an acknowledgment that there were dark places to explore, but although they were present he had choices about entering or not.

After Patrick left, I created my own emotional landscape and discovered within my image a sense of bleakness. The bleakness was a reflection of a difficult week, and I had projected that feeling onto my understanding of my client's image.

As art therapists we have the gift of our own artmaking to enlighten our struggles, our experiences of countertransference, and the messy areas where private life and professional life spill over onto each other. As our work with a client deepens, we need to take even more care to work out our own issues, with intention, in the studio. I think that our own artmaking can also be a meaningful reminder of the joy that can be experienced when doing this work. When we have a place (the art) to contain the struggles and pain, I think that we are more open to going into the next session with a sense of joy in our vocation.

Actually, asking clients about what brings them joy can be a meaningful way of moving into a deeper understanding of who they are. I like to invite clients to create some art about what brings them joy in life. Sometimes the art is very tiny! When this happens, we have some important issues to tackle, including:

- What gets you through the day or week?
- Were there things that you used to enjoy that don't bring you happiness anymore?
- Are there any small steps that you can take to incorporate one happy moment into next week?

What usually happens when clients create an image about joy is that we see some parts of life that may just have been forgotten about or covered up for a while. Sometimes hobbies appear, especially those that have been neglected due to schedules or time factors. I remember a beautiful watercolor painting of a saxophone. Sometimes pets, sports or vacations appear. In Wisconsin, cabins that were located "up north" often showed

up in images about joy, and some clients were actually able to arrange more frequent trips to those cherished secluded spots.

By looking at the joy, or lack of joy, in a client's life, I feel that I have gained a new appreciation for who they are. Hopefully, our work together will encourage growth in our ability to appreciate and nurture the joy that is possible.

Exploring
and Containing Sadness

When I worked on an extended-care inpatient children's unit, the kids would tease me about how much they wanted me to be present when they were discharged because I was a "good cryer". The legend began when I gave 15-year-old Marcus a very teary hug good-bye. After Marcus left, little Jamal ran up to me and said: "Why you cryin' about that hard-headed dude?" "Cause I'm gonna miss him, Jamal, just like I'll miss you some day. I'm happy for him that he's going home, but I'll miss him." I deeply believe that comfort with our own very real emotions is an important part of our ability to be in-the-moment-present with our clients and their emotions.

I do deserve the title "good cryer", but I'm not sharing that in a boastful way; it hasn't always been helpful and my own children are frequently mortified by my puffy eyes and teary cheeks during movies. I don't think that the ability to cry says anything about my ability as a therapist, but I think that one does need to develop a particularly honest, authentic presence when sitting with people who are sad, grieving or depressed. I think that most therapists would describe themselves as empathetic and compassionate, but many new therapists also talk about their awareness, when faced with a sad or depressed client, of their desires to "make them feel better" or "help them move on". Yet many of

our clients are surrounded by friends and family who push them diligently to "move on" instead of supporting their expressions of sadness.

Jenna was a beautiful 16-year-old, successful by any standard of high school achievement. She originally entered therapy because her mother was becoming concerned about Jenna's increasing irritability and nervous behaviors. Jenna was nervous. She was extremely anxious about making the "right choices" about her future. One evening, though, she brought a poem to our session that she had written about her grandfather who had died about four months earlier. Her poem was a sweet, tender tribute to a dear man whom she loved very much. With tears in both our eyes, I asked Jenna to tell me more about him. While she told me about her favorite memories of her grandpa, she drew pale, abstract doodles with colored pencils. I asked her to keep talking but to try a different art process while she talked, and I gave her a soaking-wet piece of watercolor paper and some watercolor paints. While the colors bled and ran, her shoulders seemed to relax and she gave up the battle against crying. She and I sat quietly with the uncontrollable paint and the messiness of her sadness, as both were given permission to show themselves. During later sessions she was able to share the anger that she felt toward her family members who appeared to her to have moved on and gotten over the death of this important grandfather.

Sometimes our clients are isolated by other people's responses to their sadness. They have friends who seem to have run out of patience for post-divorce grief, or family members who mysteriously seem to disappear during times when illness or death are present. I've often asked clients to create the masks that they find themselves using in order to get through the day. The "I'm fine" mask, the "I'm prickly, don't get near me" mask, and my personal favorite, the "I'm very, very busy so I don't have time to feel bad" mask. I think that there can be good times and places to use those protective masks, as long as there are other opportunities, as within the artmaking process, to be real. A good place to experientially be real is within the flip side or inside of the masks. We can create an image on the inside that speaks more authentically to how we really feel underneath the facade that we share with others. I'm always interested in

finding out with whom a person might share that side of their mask, and their current feeling state.

I am also very interested in what happens when I ask graduate students, interns and new therapists to create some of the masks that they use as therapists. When clients are retelling a story, do you have an "I'm listening" mask that you pull out when your mind has gone somewhere else? Do you own a "compassionate head-nodding" mask to use when you absolutely go blank? When a client creates a shocking, disturbing piece of art, do you use an "I'm cool with anything" mask to avoid stating your honest response? When clients are sad or crying, do you use a "robot" mask in an attempt to hide your feelings? I don't think that any of us intentionally uses masks while doing therapy, and I don't think that they're all bad. The "I'm cool with anything" mask can buy us a few minutes to find the composure to come up with an honest response that is also free of disgust. Part of the important work that we ask clients to do is to realize when masks are being used. We need to be aware of our own masks too. Hopefully, our own journeys are allowing and encouraging us to grow progressively true and authentic, as people and therapists.

Since I've already confessed to being a "good cryer" it probably won't come as any surprise that funerals can be rather disastrous for me, at least in terms of grief etiquette. As my grandmother's casket was being carried out of the small Protestant church in Iowa, I started sobbing. I couldn't hold in my pain any longer. I remember becoming aware that people were staring at me. I had somehow violated the cultural norms of that place. The prayers had been said, the hymns had been sung, and some degree of tidiness concerning one's feelings, was now expected.

It was with much relief that I learned that there are other cultural beliefs, traditions and practices regarding death. I had the pleasure of working with neighborhood children in a drop-in art program located in the basement of an art center in a predominately Mexican neighborhood in Milwaukee. Many of the families in the neighborhood were quite new to the United States and warmly shared their traditions with the art center, which in turn, offered space for those traditions to be

made visible to the wider community. I quickly became enamored with the Day of the Dead altars.

Neighborhood artists came in and created beautiful tributes to beloved family members who had died using many of the rituals and traditions from their country of origin, where the celebrations take place in cemeteries and homes. The altars that they created were sacred spaces welcoming back the spirits and memories of their loved ones, and included pictures, favorite possessions, food and drink, candles, and vibrant orange and yellow chrysanthemums. A cherished aunt's altar contained her favorite mixing bowl and sweater. A grandfather's included his tobacco, a pocketknife and a small glass of tequila. The artists had gathered tender, yet powerful objects in a sacred, moving tribute to people whom they loved.

I have become increasingly aware, over the years, of the cumulative effect of loss on our lives. So many people have lived through such painful losses. They often come to therapy trying to solve problems in the here and now, while holding on to unmourned losses of people, jobs, health, homes, neighborhoods, and ways of life. The loss may be primarily internal, a loss of a sense of identity or purpose, a loss of a sense of personal safety or efficacy.

There needs to be a pause in the energy that has been directed toward moving around these losses – an interruption that allows a creative response to surface. I believe that the creation of altars, or some sort of sacred memory space, can function as that still, quiet pause of awareness. I recognize that the word "altar" is a powerful word, rich with religious significance, for many people. When I talk about creating altars I sometimes need to be clear about what I mean. While people of many spiritual practices create altars inside their homes for the purpose of enhancing their worship or meditation, the altars that I invite people to create are primarily visual and tactile elements brought together in order to remember and honor.

I created space on a small table in honor of my grandmother. It held her little pink music box, a pair of her eyeglasses, a teacup that she used, several soft pink candles and a vase with flowers. I used this as a tangible

place of memory where I gave myself permission to miss her presence and be thankful for what I had learned from her. I needed that place during a time when there was no safe place during the day for me to feel my sadness. As healing grew, I was able to create an interior place of memory, and the power of that particular loss subsided a little.

My client Jenna eventually decided to make a small shadowbox in honor of her grandfather. She painted it with colors that reminded her of him, and placed her poem in the middle of it, surrounded by small rocks that she had collected on their walks together.

There are varieties of emptiness and longing that perhaps only art can tentatively touch. Tiny Laura, whose family had moved across the country, recreated her best friend's swing-set in clay. Twelve-year-old Mandy drew a picture of her mother and placed shiny foil stars around it with a little prayer underneath, asking God to watch over a mother who had vanished back into a drug-filled street life. Sixty-year-old Esther, during a particularly difficult October, celebrated her memories of her children at Halloween with an arrangement of small pumpkins and photographs from years before.

Spaces and images hold the memories, cradle the emptiness. Together we create a place safe enough to support the sadness, woven from the trust of the therapeutic relationship.

Visualizing and Expressing Anger

Robert consistently seemed immature for a 14-year-old. His rapid shifts to a tantrum-like burst of anger during family therapy frustrated everyone in the room. It appeared that in the past his family had resigned themselves to his tantrums, believing them to be an unavoidable symptom of bipolar disorder. The older and bigger he became, the scarier these episodes were to everyone. One afternoon when I met individually with Robert, I sensed an underlying edge of sadness as he spoke with anger about his biological father. I asked him if he could create some images about what it felt like to be angry, sad, scared and happy. He grabbed the pastels, scribbled a volcano and sarcastically asked if that was what I wanted. I smiled, nodded and started working on my own angry tornado. Poking fun at my tornado seemed to make him feel better and Robert continued working. He spent most of his time on the image that he labeled "Depression". In the image he placed himself down in the bottom of a deep hole. He said that the walls of the hole were slippery and muddy and that no one could help him get out. As he talked about being trapped down in the mud, his voice cracked a little and for the first time I heard passionate, deep anger coming from him. He spoke with authentic rage over the helplessness of his hole of depression and everyone's inability to help.

Even though, for the sake of clarity, I have separated out the strong emotions of sadness and anger within this book, the truth is that art has a wonderful way of showing us the connectedness, and layers of relationship between emotions. My experience with people who are either struggling to explore anger appropriately or who seem only to feel anger is that anger is often mixed up with other complicated feelings. Sometimes it is helpful to sort them out a little with artmaking. I'm not interested in compartmentalizing emotions, but I am interested in images about specific emotions. I'm curious when images about different emotions look very similar. Eight-year-old Riley's pictures of "angry" and "scared" were almost identical. When he talked about the images it became clear that it wasn't okay to be scared in his family even though there was some scary fighting going on between his parents.

Artmaking can give voice to parts of life that people may have been encouraged not to talk too much about. When I ask a client how I'd know if she was angry, I frequently hear why I *wouldn't* know. I might instead hear how skilled a person is at keeping cool, staying in control, or acting as if everything is fine. But if I put out some newspapers and masking tape and ask her to think about the last time that she was really furious and then create a monster out of those feelings, we do get to encounter some anger. The creation of anger monsters is a satisfying process complete with the physical activity of shredding and tearing the paper, the sound that the paper makes when it rips, the feel of squishing it into shapes and taping it together (Figure 7.1).

The creatures that emerge are often birthed in laughter as people connect with the playful part of artmaking. Barbara laughed as she attached long, sharp, pointy teeth to her anger monster's mouth. She gave it a crackly, high-pitched shriek and flew it back and forth over her head.

"When do you let this out?' I gasped between chuckles.

"Not very often, thank God!" Barbara sat the monster on the other end of the couch, seemingly giving it plenty of space from where she was sitting.

"What would it like to say to you?" Barbara just smiled. "No, really, what does it want to say?"

Figure 7.1 Anger monster

Barbara shifted a little and said quietly, "I'm sick of it. I'm sick of all the bullshit at work. I'm sick of kissing my boss's ass. I'm sick of staying late and helping out when we're short-handed. I am so sick and tired..." Barbara reached over and smacked her anger monster off the couch. "I am just so tired."

When I talk with people about their anger monsters, there are some questions that can be helpful, including:

- What feeds your monster?
- Where does it spend most of its time?
- Does anyone like it?

- Can it be fun or exciting to be around?
- Does it ever scare people or keep them away?
- Does it ever feel totally out of control?

Anger can permeate life so subtly that life seems to adjust around it until suddenly, as it did with Barbara, the anger finds its voice. Sometimes the voice is only allowed to be heard at night when life finally quiets so much that even the most intentional distractions fade to a whisper. Things that a person has managed to "let go of" during the day seem to drift back in the middle of the night, often stronger and more upsetting than the daylight version.

Have you ever created an image about what you think about at night? Before you ask a client to do this, you'll want to experience it yourself. When I ask people to do this I provide black paper and materials that show up well on dark paper, like oil and soft pastels, tempera paint, gel pens and glitter glue. The directive is simple: "Create an image of what you think about at night."

Carrie attacked her black paper with an abundance of 6-year-old enthusiasm. First she drew a little cricket. "I hear crickets at night." Then came some images of her pets who frequently cuddled with her at bedtime. As she continued to draw she became more serious. Soon two monster faces appeared. We'd talked about the monster problem before. Carrie would often wake up worried and convinced that the monsters would come out of their hiding places. The monsters' faces showed up bright neon green against the black paper. Their mouths were open wide.

"What do the monsters sound like?" Carrie eagerly responded to my question with angry growls. "And they get louder and louder, just like mommy and daddy, and it makes me SO MAD!" Thanks to the appearance of her nighttime monsters, we had arrived at what was really bothering Carrie at night – her anger and fear about the divorce that her parents were shouting their way to. Carrie knew more about what was going on than her parents wanted to believe and Carrie was furious with them.

The power of letting one's creativity spring from that nighttime place of darkness needs to be respected by therapists. I would never ask someone to draw nighttime images if she or he was in a fragile, vulnerable state, or if we were knowingly dealing with trauma. A young teenager who was using art therapy to work on issues related to sexual abuse used to talk about the disturbing visions of her father that interrupted her sleep at night. One day she decided that she wanted to draw what she was seeing. Within the safety of our lengthy relationship she did in fact recreate the face that she saw at night. She spoke to the image with force, telling him how she felt, her voice becoming louder and angrier until she ripped the paper to pieces. The cathartic moment had been long in coming and the safety for that kind of work had developed within our relationship of many months. She knew what she needed to do and initiated the nighttime image herself.

Dreams and nightmares often tell stories of deep fears and repressed anger. Sometimes just drawing or painting an important scene from a dream or nightmare can open up our work to important underlying issues. When I was a child I had a recurring nightmare about a huge lion searching through a big, dark house for me. When I was about 30 I decided to paint that image, and while feeling the fear again became very clear about the old childhood anger underneath the fear. The anger was something that I couldn't have spoken about as a child and instead retreated in fear from my nighttime lion.

After a client has allowed the nighttime anxieties and fears to surface visually, it can often be helpful to talk about creating a new image to take the old scary image's place. What kind of art would be helpful to look at by your bed? The art that clients have created in response to that question is as varied as the content of their worries and nightmares. My teenage client who had created the image of her father eventually created a larger-than-life-size guardian angel that we worked on together. She taped it up over her bed and it became a soothing reminder that she could create safety and peace, and that she now had power over her own nighttime.

Embracing All Images

A friend of mine who is a social worker stopped by one day to show me a picture that one of her high school clients had created. "I asked her to draw a picture of herself and look what happened!" The image was difficult to sit with. Sad eyes stared out of a face contorted with pain. The nose and mouth were twisted and exaggerated. The torso looked lumpy and stuffed like a scarecrow. The tiny stick-like legs ended in even tinier feet.

My friend Celia shook her head, "What do I say, what should I do?" As we spoke I could hear how traumatized Celia was by the image. She described the young woman as quiet, and rather plain looking, bearing no physical resemblance to the ugliness contained in the image. As Celia described some of the issues that her student was going through, we came up with some ideas about ways of exploring the difficult image with her student. But clearly Celia was still visibly distressed by what she saw. "I just can't stand it that she feels that way about herself. She's a bright, smart girl who can get through this. High school is such a small part of life. A few years from now it won't matter." The more Celia said, the clearer it became that she was speaking from her own experience in high school. We agreed that commiserating about the awfulness of high school with her student probably wasn't going to be helpful. I asked Celia what parts of the picture made her curious, what would she like to know more about? By returning to the image and inviting her curiosity

into the room, Celia might be able to sit with the image in a way that could communicate honest interest instead of shock, disgust or pity.

When we care about people we often feel terribly distressed when they reveal painful beliefs about themselves. Our instinctual reaction is often to exclaim "You are not!" or "You've go to be kidding!" When we who are parents hear our own children say "I'm stupid" or "I'm ugly", we may rush in with all our parental power in an attempt to counter the harmful statements. The last time I moved house I came across my old diary from about age 13 that graphically documented a particularly "ugly" and "stupid" year. I felt sad for the young girl who had felt such self-loathing while acknowledging that I still am not immune to her voice.

I suspect that Celia wouldn't have been so personally touched by the image if the painful portrait had been of someone else in her student's life. Celia would certainly have still been concerned about the strong emotions contained within the image but she would also have been in a stronger place from which to contain her own feelings of worry and her desire to protect and comfort.

When I encourage clients to create self-portraits I try to be sensitive to the complicated histories of self and self-image that are often brought to the picture. Anna tossed her wild pink hair and cracked her gum as she reached for the tempera paint. Her body language seemed to be pro-claiming "Screw you" while she worked. Her father had insisted that she see a therapist after she shoved a stack of books on the floor in English class and received a detention for disrespect. It was the tenth detention in that month. I was curious about the "bad girl" image that she seemed invested in.

I was a little surprised by her painting. A writhing two-headed snake had appeared on the page, each snake's mouth grinning wildly, eyes eerily glowing. "It's me, Miss Bipolar Milwaukee!" She looked up with a smirk. "It's all anyone sees. Anna did you take you meds? Anna did you sleep last night? Anna, your teacher called again." She seemed to be watching for my reaction.

"You'll have to introduce me. I don't know this snake."

Anna rolled her eyes. "Of course you do," she snapped. "I've been here three times already." Anna seemed puzzled when I told her that I didn't see "bipolar disorder" when I looked at her.

I asked, "Isn't there more to you than that?" Anna reminded me, with that tired patience that adolescents have for people my age, that she was seeing me because her behavior was out of control. So I repeated again, with firmness, that I believed that while the two-headed snake seemed like a witty portrayal of her experience of bipolar disorder, *my* experience of her was much bigger.

I wished in that moment that I'd done an image of Anna while she was working on her image. I often do that but had felt kind of tired that afternoon, and instead had watched her work. Cathy Moon writes about the value inherent in the use of the therapist's artmaking in the role of witness:

> First, witnessing can be a way to affirm clients. By therapists reflecting back to clients what has been sensed or observed, clients may experience being recognized, acknowledged, or understood. (Moon 2002, p.214)

Moon also speaks of the opportunity to offer one's clients a type of mirror within the therapeutic process: "Clients are given the chance to come to understand themselves as another human being perceives them" (2002, p.214). Since I hadn't taken advantage of the opportunity to create a portrait of Anna, I had to simply tell her verbally, without the benefit of an illustration, of my impression of her as a smart, funny, energy-filled young woman. I remember Anna saying "Whatever". But I also remember that by the end of the session the therapeutic space between us felt a little closer. I believe in respecting whatever ugliness shows up in a self-portrait, but I don't have to agree with it.

Some of the most troubling reactions to self-image work that I have witnessed have arisen from helping people connect to a younger version of themselves or to their inner child. Steven, a young man in his early twenties, was working hard on some childhood issues and had committed to learning how to take better care of himself. I invited him

to create an image of Baby Steven and he agreed without hesitation. A rosy-cheeked, blanket-wrapped, chubby infant soon appeared. Steven immediately began talking with his image, first with tenderness, apologizing for the tough years and sad experiences. The tone shifted, though, as he continued speaking and he began addressing his invisible parents, angrily asking for an explanation of their treatment of the young Steven. Tears flowed as he spoke, and he picked up a black crayon and scribbled over the infant image. Then he ripped it apart. Steven made much progress in the depth of his understanding in that cathartic art experience. I hadn't seen that particular moment coming. I think that sometimes I fool myself into believing, just a little bit, that I know where an art directive will take someone. I don't, and this was a powerful reminder.

Certainly not all of the images that I have found disturbing have been self-portraits. I have seen more than my share of parental figures thinly disguised as monsters hacking away at innocent victims, blood flowing everywhere. I have seen too many images drawn by young girls, absurdly sexual in order to somehow make sense of the fact that they were used as sexual objects as very young children. How do we keep doing this work? Where do we psychically put all of this?

I believe that art therapists have a particularly pressing need to understand the potential impact of vicarious traumatization. Not only are we hearing about trauma, but we also see representations of the trauma within our clients' artwork. These visualizations of our clients' experiences, I believe, stay with us in a way that verbal stories do not, especially since art therapists tend to be "visual people". We are sensitive to form, line, color, shapes, and we remember what we see.

Vicarious traumatization has been described as the therapists' inner transformation that has resulted from empathic engagement with clients' traumatic material (Rosenbloom, Pratt and Pearlman 1999). I am convinced that art therapists engage with this traumatic material in an especially profound depth. From my experience, we probably need to be equally proactive in taking care of ourselves. Certainly, finding good peer support, professional supervision, and building a meaningful life

outside work are all helpful themes in the effort to actively practice self-care. Attending to one's physical needs through exercise, eating healthy foods, getting enough sleep, is also important, along with maintaining some sort of spiritual practice through meditation, prayer or participation in a faith community. Staying actively engaged in friendships outside one's profession and taking advantage of musical, cultural, and physical activities, seems important. Laughing is important.

Some of the most powerful healing moments that I have experienced, after witnessing traumatic client work, have been through my own artmaking. The sooner that I can create my own images after a difficult session, the better. Sometimes I've created art as an intentional response to a particular image that I've seen that day. Other times I just start painting and let myself get lost in the physicality of moving the colors around.

I cannot predict which image, which client, what story will stay with me. Perhaps it will just be the accumulation of many images, many stories, that build up over time. I believe that putting my response out there on the table, through art, poetry or journaling, is as necessary for me as creating the image is for my client.

Thoughts on Trauma

When my daughter Grace was younger she had the habit of starting her stories about interesting parts of her day anywhere in the story. She would clearly be thinking about her story and would then just start making the thinking audible at some point. After many frustrating attempts at interrupting and pressing her for the who, what, when, where, why, I finally learned that if I was just a little patient her story would eventually come full circle and make sense.

I've come to understand that this same approach works well with people who have experienced some sort of trauma. I've learned to trust that the story starts where it needs to start. Maybe it starts with a difficulty falling asleep many years after the traumatic event, or it may start with the deep blue that matches the color of the sky on the day that the trauma took place.

Before encouraging any part of the story, I am especially concerned with how we get to know each other – even more so than with clients coming in with other kinds of issues. I believe that I communicate to any client a feeling of being accepted, a belief that he or she has value and worth as a human being. When someone is entering therapy because of a traumatic event or a prolonged personal trauma, I find it even more imperative to reflect to my client my authentic respect and my warm positive regard for him or her as a person. I find it important to communicate my interest in the whole person, and I assume that each person in

her multifaceted life still has strengths and important gifts to offer on her journey.

In her book about working with clients who have been sexually abused, Hagood states:

> Survivors quickly detect whether or not a therapist cares about them. Total acceptance of a survivor of sexual abuse is absolutely essential. (Hagood 2000, p.36)

In my work I have found that clients who have been sexually abused are particularly sensitive to the nuances of genuine welcome. They often seem to be looking for some tangible evidence that I can hang in there with them, their memories, their stories, and that I might see some possibility of a future less painful than the present. There is a therapeutic stance that suggests that therapists would do well to focus more on possibilities by facilitating hope and positive expectations (Hubble, Duncan and Miller 1999).

Our expectations as therapists will certainly color our clients' understandings about the work we will do together. Clients who have been traumatized often present with an aura of wanting, needing or hoping to be fixed. They often say that they have been broken. I've seen people whose spirits, hearts and bones have truly been broken. My expectation for their future health is important, along with my understanding of their innate wholeness and potential to heal themselves. They are not faulty or, as Hagood describes their sense of themselves, "damaged goods" (2000, p.79).

Imagine being a 10-year-old who is being dropped off at therapy. Mom has already driven your older sister to soccer practice, taken your little sister to dance lessons and now it's your turn. You're going to therapy because something bad happened to you; otherwise you'd be playing soccer or dancing too. Perhaps the best gift of therapy that day is the idea that you are still a whole, interesting, smart, good person whom I am looking forward to spending time with. Through the course of our work together over the coming months, you may tell your story, share your images and words and probably do some hard work, which will

hopefully take away some of the power of the wound. The stories themselves may need to circle around the wound. The art may touch the fragile edge and then race away, hiding rich symbols with the color and shapes.

Belinda's story started with an image of the beach, a good vacation moment with her husband. The story traveled over the weeks, from the beach to the backyard where the last argument took place, to the living room where she uncharacteristically shouted at her three little children, to Belinda's own bewilderment at her emotional outbursts, to her bedroom where her reluctance to have sex sober brought her to the realization that it was time to tell someone about what her uncle had done to her many years ago.

Jake's story started with a big picture of a door he couldn't open, then grew to a monster behind the door, and moved on to the monster graphically assaulting him at night in his bed.

Carl's story started with an image of the thumb he lost in a farm accident, and then went back in time to a boyhood memory of feeling inadequate in his father's eyes.

When I think about my work with these clients it is with a very firm sense of "walking beside". I am aware of questioning the journey, pausing often to ask myself who has chosen the direction and whether the path feels safe. Have you ever drawn an image of yourself literally "on the path" with your client? This is a valuable image to create, and there are some good questions to ask about it, including:

- What does the path look like?
- Where is it going?
- What are the perceived dangers en route?
- Is anyone taking the lead?
- Are there helpers or signs of support anywhere along the way?
- Do you want to be there?

Isabel was a wonderful new therapist, fresh out of grad school, whom I had the pleasure of supervising. She was eager and full of energy for the work, but one morning when she came in to see me she was clearly dragging. She was working individually with a mother in one of the families that the treatment team was working with. The mother had a troubled history and a complicated mental health background. Isabel was exhausted. "I don't know what to do anymore. We seem to agree on something that she's going to try, and then she does just the opposite. I feel like a failure, a joke." Isabel slumped in her chair and a tear trickled down her cheek. "I don't know what I'm doing."

We talked a little more and then I suggested that she draw a picture of the path that she was on with her client. Isabel wasn't an art therapist, but she was willing to try anything at this point. Her image emerged quickly, and featured a dark, narrow path up a sharp cliff. Her client was one tiny step ahead of her, and Isabel held onto her client's arm with one hand, apparently trying to prevent her from falling off the cliff. Isabel held a lantern with her other hand. "I'm tired just looking at this, Isabel!"

Isabel's image was not an uncommon response to this work. How often new therapists seem to be tempted to take on this role as the one keeping the client from tumbling over the cliff. So we played a little with what could help out, both with the image and the therapeutic relationship. We played with the idea of giving the client the lantern. Could Isabel trust her to carry the light? We played with the idea of letting go – would her client truly fall off the cliff? What if there was a trampoline or a nice warm lake underneath the drop-off. Maybe the picture needed some more supportive folks on the path. Perhaps an army of forest elves? As we laughed a little about things we could add to the image, Isabel began to understand that there were other ways of looking at the relationship with her client too.

When studies have looked at the variables of what encourages effective therapeutic relationships, it is clear that those variables are enhanced when the client perceives a strong alliance with the therapist (Murphy 1999). In art therapy we are able to help the client experientially understand the alliance by making art with our clients.

Bruce Moon has written eloquently about his own artmaking and his powerful connection to the studio. He poses the question about why indeed should we art therapists be making art, and states, in part:

> We make art in order to responsively interact with clients. We make art in order to engage in a kind of spiritual practice and to participate in soul-making. Finally, we make art in order to form authentic relationships with others and with ourselves. (Moon 2003, p.19)

I believe that there is no more important need for authenticity than in the relationship with a client who has experienced some sort of trauma. Our words and actions must convey our honest willingness to go with the client, even though we can only partially appreciate the depth of his or her experiences. The phrase that I never want to hear an intern use with a client is "I feel your pain". You don't. Neither do I. We may witness it, hear it, see it, and perhaps understand it, but only the client can truly feel it.

I have learned that my most sensitive witnessing often takes place in that side-by-side artmaking with my client. When I do this, my own trust in the artmaking and my own willingness to expose my images seem to provide a gentle welcome to my client. Welcome to the paint, welcome to the paper, welcome to deep self-expression, welcome to this safe place for your story.

I have heard art therapy students say "I couldn't do that. I get lost in my art". I deeply know what it is to be lost in one's art. The experience of being lost in artmaking is truly a gift. I am so thankful for those transcending moments. Getting lost in one's art is a uniquely profound experience. I believe, however, that we can develop an ability to keep the "observer" part of ourselves awake and present when we make art as therapists in session.

Does that kind of artmaking have any value? Is it possible to be present for another person and still make art? My experience of art is that any moment of artmaking has value. I don't let myself get "too lost" when doing art alongside my client. Making art while being tuned in to

what my client is doing feels a little bit like listening to books on tape in the car. I am enjoying a good story but I am completely aware of what I need to do as a driver. If I want to truly savor the experience of the story, I'll read the book when I'm all alone at home. I find great satisfaction in experimenting with shapes and color while working alongside my client. I share my enthusiasm for the process of creating while demonstrating that artmaking can be as simple as a spontaneous gesture with a crayon.

"But something might come up for me in my art" is another objection that is voiced. Yes, something will come up for you. Art is honest and true and undoubtedly your images will have meaning. They may reflect your happiness about a new love, a lingering sadness, or they may present visual reminders of a painful situation. One afternoon I was exploring a beautiful shade of blue in a painting of a sky, and suddenly the clouds took form and turned into a blue bowl. Years before, an image of an empty blue bowl had symbolized my growing unhappiness in my marriage, and seeing the bowl again felt like someone had grabbed me by the throat. Before tears could form I told myself "later", internally promising a return to the bowl when alone. I played a little bit with other parts of the sky, mostly watching my client, tuning in closely to the huge tree that was growing in her image.

Art is too powerful to be predictable. Painting clouds seemed like a safe enough idea. I think that it is possible to say hello to the disturbing line, shape or form, and understand in that moment of potential risk that I will agree to return to the content or meaning later on. In verbal therapy, we can be aware of all kinds of memories or thoughts that float through our heads while listening to our clients. We trust that we can stay present to our client's issues and not get distracted by our own, and that we will use wisdom in what we choose to disclose. When my client asked me what my blue bowl was about, I didn't lie, but I also didn't elaborate. I just explained that I thought that it might be about an experience of emptiness that I should probably spend a little time with later. While I didn't choose to use that particular moment of disclosure as a moment to connect with my client's own therapeutic issues, it is possible for one's image to be a sort of therapeutic bridge into an important issue.

Emily, a second-year graduate student, was doing some in-home therapy with a family in order to make the entire family's participation in therapy more possible. During one of the sessions, while the family was creating art, the grandmother suddenly appeared to be having a heart attack. Emily helped with the children while the parents called for an ambulance. It turned out that the grandmother was fine and she was able to come home from the hospital the next day.

The next week when the family gathered again to make art, Emily created an image about how scared she'd been the week before. It was as if she had waved a magic wand over the family. Images and conversation suddenly took on a more honest tone, and family members shared with openness how they had felt. Grandmother was able to say that she couldn't remember many of the details but that she had been terrified. The mother responded by talking about her own fear that her mother might die. The youngest child drew a dramatic black image of the fear that he had felt in his stomach. Emily's honest artmaking had somehow given permission for a door to be opened. I think that sometimes doors have been shut for so long that people forget why they closed them in the first place.

Certainly there are times when simple witnessing is the best accompaniment for someone's art process. There are clients who deeply appreciate the sense of being held within the therapist's attentiveness. It sometimes feels as though the therapeutic holding space exists primarily because of my watchful attention. Perhaps the best way to know what creates safety is to simply ask: "I can make art alongside you or just be here with you while you make art. Do you know what you might be more comfortable with?" A choice is offered from a caring intention held by the therapist, to provide the therapeutic container best suited for the work of that moment.

Moving Toward Healing

Janey flew into the room bringing a gust of fresh spring air with her. "Mom wants to come in with us today." Janey was 11 and had come to enjoy our time together, even though she was in therapy because she had been sexually abused by a neighbor boy. We'd been working together for about seven months. Karen, her mom, looked worried. When I asked them how things were going, Karen immediately began telling me about a slumber party that Janey had attended on Saturday night. Apparently the girls had rented videos and watched a movie with much sexual innuendo. Janey had made it through the evening all right but the next day had mentioned to her mother several times that she was thinking about the abuse again. Karen wanted to know how much the abuse was still on Janey's mind and how long it would be until Janey wouldn't think about it so much. Janey said that she felt confused because the "bad thoughts" would go away and then come back at "weird times". "Like the other night. I was in the bathtub and I started feeling funny down there." Janey and I had talked a number of times about the fact that sometimes the abuse had "felt good".

Karen squirmed a little in her chair. "I'm really worried that she's still thinking about it so much." With that she stood up, smiled and said that she would give us some time alone.

Janey seemed puzzled and said, "I don't think I think about it so much anymore."

I got out a big container of tissue paper and a large sheet of white paper. "Let's make a picture about what you think about. Choose a color for each kind of thoughts that you have, happy thoughts, angry thoughts, thoughts about school, thoughts about friends and thoughts about the abuse." I showed her how to paint liquid fabric starch over the tissue paper to make it stick.

Janey figured out right away that she could layer the colors on top of each other creating all sorts of interesting shades and textures. When she was done she was clearly pleased with her image. Swirls of turquoise and lavender were juxtaposed with bright blobs of yellow. Small splotches of black appeared here and there, interspersed with the other colors. "I like the yellow the best. That's when I think about riding my bike and playing outside." She pointed to the black spots and talked about how the "bad stuff" still popped into her head. "But not so much. It would have been all black in September." Janey invited her mom back into the room. We talked about how normal it was to have some black spots. Karen was happy for all the bright places in the image, but was able to share with Janey that she just wanted all the black to go away forever. Janey, in her own wisdom about herself, told her mom that she knew she could live with some black spots, just not too many.

Images of healing are amazing gifts in this work. Sometimes it feels as though a special messenger has arrived with long-awaited good news: "I've come from someplace deep inside you and things are getting better." Shaun McNiff refers to paintings as all kinds of helpful messengers, helpers, visitors and guides, and views the imaginative interactions that can spring from this kind of understanding as a natural extension of the practice of dialoguing with images (McNiff 1992).

Barbara chose, one day, to create a painting using only black and white paint. The black symbolized her deepest truth about herself and the white was the "shallow stuff" that she felt most people knew about her. The shades of gray that appeared were beautiful, an integrated mix symbolizing, she believed, the more honest way that she was presenting herself in the world. She told me later that she taped the image up near the place where she kept her car keys so that she could look at it on her way out into the world in the morning.

Creating a black and white image can be a powerful experience. It allows us to play a little bit with what feels "black and white". Often as our exploration progresses, we grow in our appreciation of the shades of gray that do seem to be present within many issues that confront us. Sometimes a client will struggle to keep the colors separate, trying to avoid the mess of the gray. Other times, a client may layer and blend the two until the gray is solid, fog-like, and seems all encompassing. Important therapeutic discoveries can be made when someone willingly enters into the gray. The point when the fog finally lifts can be a moment of grace. Or it may feel more like a process of gray, a slow moving journey through, until the glimmers of bright sky eventually overtake the fog. The painting of the experience seems to provide a guidepost or trail mark for where one is at.

Another art experience that feels appropriate for this stage in therapy is the use of a full body tracing. I am cautious about using this directive and I believe that it requires a well-established therapeutic relationship in order to safely hold this work. I am cautious because coming face to face with a life-size image of oneself can be at the very least unsettling, and sometimes can be incredibly painful. Ten-year-old Mack's image brought up all kinds of fears about his ability to take care of himself when he saw his skinny arms and legs. Forty-three-year-old Regina wept when she first looked at her body tracing. I cringe when I hear about therapists, social workers or teachers who use this experience lightly. To appreciate the full potential impact of this art experience, therapists should try it themselves:

1. Tear off a piece of paper that's at least six inches longer than you.

2. Lie down and ask someone to draw around you or draw around yourself the best that you can.

3. Fill in the image using any art media you prefer.

4. Draw or color in where you carry or hold pain, physical and emotional.

When I've asked relatively healthy, self-aware graduate students to do this, the entire class is often visibly moved when the results are shared. When we sit with a full-size image of ourselves, we witness our bodies as they exist and we see where the pain has been felt. We need to appreciate, from our own experience, how powerful this can be before we ask a client to do it. The potential for catharsis is real. The potential for healing is also present.

Without prompting, people often feel and see clearly what they need to do to visually deal with the pain. I've witnessed healing ceremonies evolve from simple rituals of painting over or cutting out. I've watched as hearts are literally sewn back together, vocal cords freed from dark blockages and tears transformed with glitter. I've also watched people triumphantly create healthy, glowing images. Clients often use the full body image as a visual place to note change that has occurred during the therapeutic journey. A young woman proudly drew breasts and pubic hair on her body tracing, and could say that she was turning into a woman, despite her fears around developing into a visibly sexual person.

Done more than once, the body tracing can evolve into a type of journal that becomes a place to record changes in perception, feelings and sensations. Journals, in general, are certainly widely used in many types of therapy. The image-based journal can be particularly helpful when we need a place in our work together where it's appropriate to look back on where we've been so that we can plan together where we still need to go.

One little client's journal grew into a self-made baby book. Due to a sad succession of foster home placements, Janelle had no record of her first four years of life. At age 8 she felt sad when she watched her adoptive mom work on a baby book for her new little sister. So we decided to fill in some of the blanks from her past with art. "What do you think I looked like as a baby?" became an important issue for her. Since she had huge brown eyes we decided that her eyes were probably something that everyone noticed when she was a newborn. We both drew pictures of baby Janelle with big brown eyes. I drew her smiling because of her current wonderful sense of humor. Janelle was an active,

athletic 8-year-old, so we guessed that perhaps she was an active toddler, and she created a picture of herself at 2, racing around the house. We took things that she knew about her likes and dislikes, and incorporated them into images of her during earlier years. She was crazy about bubble-gum ice cream, so we worked together on an image of her at about age 5, eating a huge ice cream cone of her favorite messy flavor. She loved going to the park and we made a painting of her flying through the air on a bright red swing. Our collaborative work, piecing together images of what we thought we knew, gave Janelle an opportunity to express her sadness and frustration over what she called the "missing times". It also gave us a touching record of her understanding of who she was. She was eventually able to share her baby book with her adoptive parents. We used her creation as an opening for talking about all of their hopes for the future of their new family.

It often seems important, as clients are at a point of new understanding about themselves, to connect with the old understandings as a way of acknowledging the work of the journey. If we do this enough in advance of termination we have some space to map out the "what next" in a way that avoids premature anxiety over the completion of our work. The art that has been created during our time together can be a beautiful record of healing. If we wait to review this amazing visual documentation until the last session, we miss the opportunity of using the truth of the art to help us figure out any unfinished business.

Part III

Moving Toward
Good-Bye

Termination Issues

If the initiation of a relationship through artmaking is, indeed, a little unusual, I want to suggest that the termination of the therapeutic relationship is a strange process too. Think about relationships in your own life that have ended. Whether through death, divorce, moving away, or mutual agreement, most relational endings are at the very least unsettling. Some relationships end abruptly, loud and fast as the slamming of a door. Other relationships seem to die very slowly, fading rather passively, much as the darkening evening sky. Relationships that do have planned endings, such as a divorce or a move, probably weren't initiated with the understanding that they would end. There is often an element of surprise or betrayal present within the endings.

A good way to reconnect with your own experiences of relational endings is to create some art from whatever comes to your mind when you think about the word "good-bye". I ask graduate students to connect deeply with the word "good-bye" before thinking about their first termination with their clients. The images that surface are often terribly sad, brimming with remorse and loss. I am hopeful that by bringing to consciousness whatever "good-bye" has meant to us, we can understand what ingredients go into the making of a healthy good-bye. After sharing their artistic responses, I ask my students to explore elements that a healthy good-bye could encompass within the context of the therapeutic relationship. From my own experience, these elements include:

- an agreed timeframe with a degree of flexibility
- a sense of what we will work on in the time left
- a review of the therapeutic journey, including the art
- some ideas about community resources, if appropriate.

Depending upon where one works, some of these decisions that happen during termination may be impacted by agency policy or guidelines. Sometimes the treatment plan must reflect, from the first session on, what the discharge plans include. In other places the length of treatment is rigidly established from the very beginning. But preferably the therapist and client are able to agree upon what the end of their time together will look like. How it looks will depend much upon where we still need to go together.

Clearly, I use the metaphor of journey extensively as I think about the therapeutic relationship. As we begin talking about the end of the journey, I like to encourage clients to visualize what the path might look like, particularly the issues that may still be looming ahead. When I ask clients to visualize this, I invite them to create a "map of where we haven't been". Sometimes the places that we haven't been are very close to where we have been. Barbara, for example, drew an explosive-looking fire in the middle of her map. The fire was about her anger at her father. We had explored other relationships in the context of her anger, but not that one. Another client drew a waterfall that we still needed to negotiate, but noted that she felt that during the course of our work together we'd already diminished the sharp rocks that used to be at the bottom of the waterfall.

It is possible that something much bigger and more important than anticipated could emerge in the art at this point. An adolescent boy created his map out of clay and as he talked about his apprehension about a particular clump of trees, he pulled a wild-eyed monster out from the clump with a convincing growl. When I told him that I was surprised by his monster, he said that he'd been saving it for the end of our work together. The end of therapy was when he wanted to talk about an older brother who lived far away. The issues that we'd already explored had

centered around anxiety and he was feeling pretty confident about that work. As we talked about his clay monster it became clear to both of us that we should adjust our timeframe a little.

As the clients' art shows us the unfinished business, the client is empowered to approach the ending of our relationship with a sense of control that he or she may not have felt before in any other relationship. As the client is encouraged to proactively address her needs, we minimize the potential triggers around abandonment and loss.

When a client does react negatively to the termination process, we have time to work together on the pain and anger if the process is able to be a gradual one. The therapeutic relationship, even though structured to end, often has developed a level of intimacy that a client hasn't experienced before within other relationships. Voluntarily pulling back from that can be extremely difficult. Sometimes the feelings are too much to tolerate and clients will end the relationship prematurely by "forgetting" the last session. In residential or day treatment work, clients may act out or otherwise sabotage their participation in a final session in order to avoid dealing with strong emotions that have been triggered. I was persistent in tracking down clients in those settings so that I could say, "I need to tell you this – I need to tell you that I'm going to miss you and that I feel sad about saying good-bye to you."

Saying good-bye to a client will take on different nuances depending upon how one views the therapeutic relationship. If it has truly been a partnership and not a series of interventions, our clients would seem to be in a stronger place in terms of taking responsibility for their own good work and healing.

Revisiting a particularly meaningful art experience can be a visual recognition of the change or healing that has taken place. Perhaps the client created a crystal ball image during the first few weeks of therapy. It may be important for the client to create a new image of the future if his understanding about who he is and what he wants for himself have shifted over the course of our work together. Self-images are interesting to repeat because of the impact that the clients' new insights may have on their concepts of self. We can compare the different images and see

the evidence of what has shifted or altered. The client is able to see the important work that he did as he compares the different versions of the art experience.

Of course we may discover things that didn't change. Kay created another mandala toward the end of therapy about what was currently going on inside her. We compared it to one created much earlier in our work together. The unhappy-looking frog still crouched in a tangle of gray lines near the bottom of her mandala. We both knew who the blue frog was. Despite much growth in her own self-esteem and new insights into the source of her feelings of frustration and anger, Kay continued to feel fairly dissatisfied with her relationship with her stepson. Nothing seemed to work with Todd and even though Kay had decided to step back emotionally from the relationship, she continued to feel frustrated by it. We played a little with the images and for a few minutes even had both versions of the frog talking to each other, but ultimately she decided that she would need some time before she could rid her mandala of this reptilian negativity.

After Kay left I found myself taking a look at the source of my own blue frog frustration. I remember absentmindedly playing with the modeling clay while returning phone calls. When I finished the last call I realized that I'd made tiny versions of Kay and her husband and of the frog. The frog was safely incarcerated in a tiny clay box. I'd bumped up against my own wishes for a "happy ending" for Kay. Boxing up Todd for her probably wasn't the most therapeutic response, but it certainly felt good.

Validating the Work that was Done

I have always loved folktales, fairytales and myths. Much like a compelling painting, they seem to pull me into another world and help me see different ways of understanding human experience, particularly my own. When I think about termination issues, I like to refer to the Slavic folktale about an older childless couple who create a child out of snow (Evetts-Secker 1996). The child comes to life and they all live quite happily, until one day the little girl melts, as deep down we all know that snow people must do.

It seems to me that this is a good metaphor for our work with clients. We put much work into shaping the relationship. We participate fully in the relationship, all the while knowing that it will need to end. The boundaries of the relationship are such that it has to end. Certainly, some therapeutic relationships last for years, but my experience in most settings is that they are time limited. We don't, however, always feel sad when our snow people melt! Termination often feels great, to both the client and the therapist, when there is a shared understanding about the good work done and the progress that was made. In honesty, termination probably feels good for less noble reasons too. Perhaps the client just needed a break from being in the process. Perhaps the therapy had gone as far as it could at that time. Perhaps there was an unconscious

understanding that therapist and client had gone as far together as their own human limitations would allow.

After we have finished our work with someone, it is certainly helpful to spend some time reflecting on what we learned about ourselves and the therapeutic process during that relationship. A journal entry, a poem, an image, a sculpture, even a dance, could capture the essence of our response to the relationship. Sometimes I've used a particular form of meditation to recenter myself:

1. Take a small lump of clay that feels comfortable in your hand.

2 Put on some quiet, soothing music.

3. Close your eyes and be conscious of your breathing while shaping the clay. I usually shape it into a small bowl and there always seems to be a natural stopping point in the process.

4. I place the small bowl on a shelf where it dries. Sometimes I reflect on the container as a metaphor for the relationship, other times I just let it be, releasing attachment to what it was.

Therapists often tend to look at their own work when a therapeutic relationship is coming to a close. It seems to be an appropriate opportunity to look back on how therapy went and spend some time in self-reflective evaluation. I don't know that we're often taught how to evaluate this kind of work. I've been a part of family therapy treatment teams that did a nice job of looking at their work at termination. They talked about what had been successful, other options that could have been tried, and warmly supported each other as competent, caring therapists. When one is all alone providing therapy, the evaluation challenge becomes more difficult. Even when blessed with good supervision, one may be found staring at a treatment plan late at night, trying to see what really happened. Actually, looking at the treatment plan for some verification of good work is probably not the best idea. The treatment plan will certainly tell us where we thought we would go, but probably doesn't reflect the most meaningful therapeutic moments.

Do we rely on whatever our clients have said about their experience? What are we hoping to hear? I think that secretly we want to hear that through our work together the client feels empowered to move ahead toward a healthy, happy life and is free from whatever burdens he or she entered therapy with. We might not hear this. We might hear how hard therapy was; how other parts of life that hadn't seemed related to the original issues were now all changed or altered. We might hear how parents or spouses have reacted to the new ideas and changes. Did we support a therapeutic journey or open Pandora's box?

I can think of four simple questions that I find valuable to ask myself when my client and I have finished our work:

1. Was I fully present, open and available?

2. Did I process my own triggers and issues regarding this client?

3. Did I seek supervision as necessary?

4. What did I learn form this relationship?

Again, as we look at out work with a client, we have to filter our evaluative questions through our own understanding of our role as therapist. If we come from a place of needing to feel in control or if we believe that we are the change agent in the relationship, or that we have superior knowledge of the client's issues and truly do have the answers, we will undoubtedly be more critical of how therapy turned out. If one believes in interventions "done to" a client, or in some kind of prescriptive plan, then I suppose that one must feel quite accountable for success or the lack of success.

Going back, once again, to the journeying with metaphor shifts the nature of the review. If client and therapist are accountable to one another for the path that was taken, then progress or lack of progress can be viewed within the mutuality of the alliance. No one ever "fails" therapy. Perhaps the path didn't go where we thought it would, but we probably encountered some interesting stuff along the way. In art therapy we get to look at the "stuff".

We may have taken advantage of the opportunity to review a client's art earlier in the process, perhaps at the point where we began thinking about termination. The very end of therapy is another logical time to take another look. Robert was almost 16 when we finished our work together. I had worked with him individually, and with his family for about a year and a half. We had done a lot of art to look back on! Some of it had vanished, probably into the depths of Robert's bedroom, and some pieces he had felt the need to destroy. We still had much to look at. Robert's family was one that I had seen in-home, so we laid out their work on their long dining room table. The timeline and other big family pieces were spread out on couches and chairs.

Congruent with his usual approach to life, Robert jumped all over the place, backwards and forwards, when looking at the images. No nice chronological viewing, thank you very much! In his pleasure at feeling like the star of an important art show, he directed his parents and me to the last few images, which pertained to his future plans. Of course I had hoped to eventually encourage this, but Robert had a way of taking care of any illusion I might secretly harbor about being in charge of the session. He had clear images and ideas about what the future would be. He was excited about the prospect of transitioning to a "regular" school, partially for the opportunity to meet girls. He had already applied for an evening job at a grocery store within walking distance from his home. He could admit to no good reason to become more cooperative with household chores, but he did laugh when his stepfather confronted him with an image from the early part of our work when Robert had drawn himself at war with a sink full of dishes. The best moment in the art review came when his mother was thoughtfully studying a section of their timeline. Tears came to her eyes as she told Robert that she wasn't afraid of his temper anymore.

Sometimes when I review the art created during our sessions with a client, I ask my client to pick out the images that she or he feels most empowered by. Which one made him feel strong, healthy, happy, confident? I may suggest that he create a tiny book of reminders of those images (Figure 12.1). The book can be as small as two or three pages and stapled, or laced together with yarn. It may be only three inches square.

Figure 12.1 Tiny book

The important thing will be its ability to visually remind my client of his good work. A red star taken from a large morning sky image might be recreated within the book to remind the client of his powerful under-standing of renewal and hope. Or he might choose to draw again the wise fish that showed up one day in an image about change.

As much as I value this planned-out approach to termination, the reality of the work can be that time runs out before a thoughtful review of the art can happen. Our clients' lives are as complex and unpredictable as our own (sometimes much more complex and unpredictable), and a sudden job change, illness or move can abruptly bring therapy to an end, even though all of those events are in fact valid issues to bring to therapy. Other clients, particularly children, aren't entirely in charge of their ability to participate in therapy. Mathew began his work with me during a time of upheaval in his family and we both knew that he might have to move up to the northern part of the state to live with his father. In work

with clients like Mathew, I become acutely aware of the value of the here and now. I have to trust that there is meaning to the work of today whether we are able to meet again or not. There are settings for therapeutic work where this is the norm and not the exception. The nursing home where I knew that Gert wouldn't remember me tomorrow, the shelter where Jasmine's family paused in transit, the drop-in art center with its entirely fluid clientele are all examples of the need to find value in the relationship and art of the moment. The "getting to know you" and "say good-bye" phases of therapy seemed smooshed together sometimes into one or two brief sessions. Depth could be surprisingly present too, as perhaps the knowledge that we only had a fleeting opportunity made the best use of that moment terribly important. The work in that brief, limited encounter might be as full of color and meaning as a powerful sunset that flickers briefly before the darkness appears.

I've become a much bigger fan of sunsets since moving to New Mexico. The colors and light against the high desert landscape are breathtaking. I used up quite a bit of film at first, trying to capture what I was experiencing. I've gotten much better, over time, at just being present.

Anticipating the Future

I grew up in a community in Illinois that borders the Mississippi River, right where the Rock River flows into it. My family went fishing on the Mississippi and I learned how to ice skate on the edges of the Rock River. But living near those rivers presented an annual challenge. Every year when the snow melted and the spring rains fell, the area flooded. My father owned a drug store and was active in the business community and I remember that he would go help fill sandbags to protect the downtown. We didn't live in a neighborhood that flooded but we'd go for car rides to see how high the rivers were getting and always someone would look at the houses that were in danger of being washed away and say, "Why do they live there? This happens every year!"

Sometimes I'm reminded of those predictable floods when I explore termination issues with a client. When we look at challenges or difficult situations that are likely to reappear in the future, it's helpful to see if we can envision or create a new response.

Thanksgiving was a predictable time of stress for Barbara. She and her siblings would congregate from across the country and reconnect at her parents' home. As Barbara looked at images containing anger about many of those family relationships she realized that even though she felt more confident and healthy, the same family dynamics would be present again when they all got together. We decided to make some art about other possibilities for the future.

Both of us started laughing when we placed our images together on the table and saw what each other had envisioned. I had glanced at Barbara's image while I worked and seen people gathered around a dining room table. I hadn't seen the final touch which was Barbara standing in the middle of the table, screaming, one foot poised triumphantly on top of the turkey. Barbara explained, while smiling broadly at her triumphant if rather edgy portrait of herself, that it might be time for her to take charge of those family ordeals.

My own image was much calmer and featured Barbara serenely watching a tropical sunset from her blanket on the beach. My thoughts behind my image were "you have a choice about these holidays". Both images were like a breath of fresh air blowing through a dreaded family holiday. The art had shown us that creative options were possible, although, just like the folks who choose to live on the banks of the river despite the annual flood, Barbara had reasons to show up each year at her family's gathering. The option of doing something completely different didn't really feel much like an option to Barbara. Her own image helped her play a little with the idea of being more assertive, even though we both knew that the likelihood of her arming herself with gravy and cranberry sauce was pretty unlikely.

Barbara eventually decided that she could more happily attend the holiday meal by putting a limit on the time she spent there. She decided that she wouldn't come early and help with the preparations but that she could stay for cleanup. She thought through some strategies for disengaging from disagreements, and planned, if she felt like it, to spend a little time with several of her siblings the day after the holiday.

Artmaking can help us identify how a client visualizes issues that will more than likely recur. Our clients can visualize and create the next thunderstorm, the next parental argument, or the next lonely weekend. If I feel as though it could be helpful to create a very concrete image of particular fears and newly developed skills, I invite clients to work on a visual swamp.

The swamp idea came from the work of two gifted recreation therapists whom I worked with on an inpatient unit and from whom I learned

much. Jeff and Dawn believed in helping the kids who were nearing discharge to experientially grapple with the issues that would undoubtedly face them back at home. Through the use of movement, cooperative activities and artmaking, the kids were encouraged to look at what they anticipated might be their biggest challenges. The swamp was an activity that Jeff and Dawn developed to help the kids do that. I've changed it a little over the years but it remains fairly true to their original process (Figure 13.1).

I draw both edges of the swamp on opposite sides of a large piece of paper. I also draw some steppingstones going from one side to the other. I ask my client to identify what's on either side of the swamp and fill in

Figure 13.1 The swamp

the steppingstones with images or words about what she feels will help her get to the other side. There is plenty of room in the watery, swampy area to draw any obstacles or issues that might emerge from the murky depths.

Anna was interested in getting to the place where she absolutely wouldn't cut herself anymore. Her steppingstones were filled with images about what she does to take care of herself and whom she had learned she could rely on during difficult days. I asked her to draw whatever obstacles or fears might still be lurking in the water. Anna drew an assortment of alligators, one large enough to compete with the Loch Ness Monster. As she talked about her image she realized that her steppingstones did feel adequate to the fears or issues surrounding them. She spoke with pride about her intentions to continue on her path toward health and good care of herself. We agreed to spend some time during our last few sessions dealing with the issue that the "Nessie" symbolized. Anna's sense of support, both internal strength and external sources, had blossomed dramatically during the past few months. It seems important to help clients identify what feels supportive and how to access that support during our last few sessions.

A weaving process can be a helpful way to bring together the many different and sometimes seemingly unrelated aspects of the therapeutic process. A weaving can create a type of support net symbolizing the strengths, resources and people that when woven together can be a visible reminder for the client that she has what she needs in order to move ahead. I try and encourage people to make the most simple of weavings. Children can weave bright strips of paper, yarn and ribbon through other strips of paper that have been glued down at the ends to a sturdy piece of paper or cardboard. Sometimes I give my client a piece of cardboard that has been wrapped with yarn, creating a simple loom. The client is encouraged to choose anything he or she likes, to weave between the lengths of yarn (Figure 13.2).

Nine-year-old Paul chose a piece of soft fuzzy lavender yarn to symbolize his grandmother. He carefully wove it in and out, talking about a new after-school plan that included spending some time at his

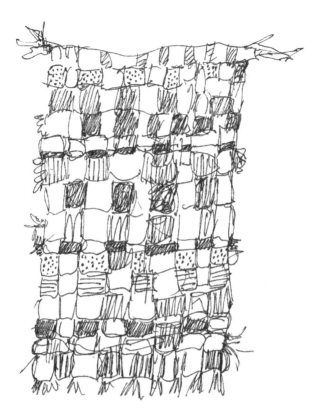

Figure 13.2 A weaving

grandmother's house. Next, he took some small sticks and wove them through the yarn, explaining that they reminded him of his cousins whom he played outside with sometimes. I asked him if he knew anything about himself that would help fill in the weaving. He thought for a while and then picked out a bright, shiny ribbon. "I can tell my mom when I'm mad about stuff." We agreed that this was a very important strength that he'd worked on in therapy and he wove the ribbon into his creation. He also took a strip of paper and wrote "Dad, Dad, Dad" on it and then wove the strip in and out of the yarn. "I think I get to see him this summer," he said quietly.

Paul decided that he would put this last art therapy creation up on a little bulletin board in his room. Before Paul left that day I pulled a small bag of rocks out of my desk drawer, and asked him to choose one. He

chose a shiny, polished green stone. "When you look at your stone I want you to remember all those strengths that you have that we talked about. And I want you to have this little jingle bell too."

"What's the jingle bell for?"

I made it jingle a little and said, "The jingle bell is to remind you that what you have to say is important. Your mom needs to hear what you think about things." After a quick hug, Paul ran out to the waiting room, excitedly showing his mom his weaving, his rock and the jingle bell. I handed his portfolio to his mom and we spoke for a few minutes before saying good-bye. I felt a little sadness as I walked back to my office. I picked up a picture that he'd drawn for me to keep. It was a funny little portrait of me playing with clay. I felt good about the work we had done but I couldn't help wondering if mom and grandma would continue with the structure and consistency that we'd all seen work well with Paul. I looked more closely at my portrait and smiled at my glitter-glue hair.

These little art exchanges are part of the good-bye ritual. Sometimes the ritual involves doing something very intentional with important pieces of client art. Zack insisted that we take a particular image out of the "monster closet" where I kept scary art safe, and go outside and burn it. I think we both felt some relief as we watched the symbol of Zack's pain crinkle up in the flames and vanish. Burning, burying and smashing art can feel powerfully freeing.

Usually the ritual is much more gentle. Maybe we'll exchange small images. I usually create a small symbol of a wish that I have for my client's future, or an image that contains some positive quality that I've seen grow within my client. It is my opportunity to reflect back, visually, my experience with my client and my continued positive regard. It feels appropriate to me that we end therapeutic relationships with the same care and respect for the client and the art as we started with. Creating an intentional, planned, healthy good-bye helps the client feel held and supported, even as we are moving away from each other. The tender authenticity that often permeates these final images and words comes from a depth of understanding nurtured by our knowledge of the

journey that we've been on together. There have been other journeys and there will certainly be more. I seem most able to move forward on other journeys with other clients when I have given good attention to the one that needs closure.

Abby smiled her funny little missing-tooth smile when I asked her if she'd like to make a tiny book of helpful pictures from our work together. She said that she'd only need one little piece of paper. I watched her as she carefully drew a tiny square. Abby and I had worked together for about a year, exploring all kinds of tough issues related to sexual abuse. She was a resilient little girl from whom I had learned much. "Bet you don't know what this is!" she said as she handed me her little paper.

"You better tell me", I said. "You know what a bad guesser I am." Abby laughed. She always got a kick out of the fact that she was the only one who knew the real story of her pictures.

She scooted closer to me on the couch, and said that it was a window. I must have looked puzzled. "It's a window. It's a window open at night. I'm not scared anymore." Tender wisdom made visible – the window is open.

Epilogue

A group of students ready to head off on their internships sat in a circle sharing nervous laughter and promising to stay in touch. We'd already talked about last-minute concerns regarding the paperwork and recordkeeping that went along with all of the other internship requirements. I felt completely confident that they were each uniquely ready to move on into the next phase of their learning and work. Six months ago they were just beginning their practicum work and the discussion had been very different.

At that earlier point, before actually sitting down with a client, the students' fears centered around a common theme. The theme had a few variations but all versions seemed related to the idea of blank space; not the blank space of the white paper that has the reputation for halting one's ability to be creative, but the blank space of time. The time when the therapist's mind goes completely, totally blank and the clock that's hidden discreetly across the room seems to stand absolutely still. Or the moment when the client asks an opinion or question and a magic eight-ball would have a better chance of coming up with a reasonable answer. Or the experience of looking at the client's art and having no words, no thought, no response.

I'm pretty sure that the group was looking for me to say that these most-feared moments just wouldn't ever happen. I couldn't say that. What I could say was that when those moments came the new therapists would move through them. They would breathe and feel their feet

solidly connected to the ground, and they would be present for their clients. Being present doesn't mean being super-therapists, having all the answers, or sitting, poised confidently in their chairs ready with insightful comments for any situation.

The relationship, even in its very initial stage can accommodate a blank moment. The client is there because of how life feels and is most naturally focused on what is or isn't coming out of *her* own mouth. And the art is there. If no art has shown up yet, the blank moment might be a good opportunity to invite it into the room.

I know that many new therapists have been blessed with wonderful supervision. One of the best gifts of an internship or first job can be a supportive supervisor who listens, encourages and challenges. Supervision, when it feels open and non-threatening, can be the best place to talk about the blank moments or inadequate feelings. Certainly art therapists are frequently supervised within agencies by people who are not terribly familiar with art therapy, but they may be more than familiar with the population, the agency, the community and the therapeutic issues. The need to be concurrently supervised by a registered art therapist is important, particularly when one finds oneself the first or lone art therapist on the job.

There's just something a little different about how we work. Even in the most DSM-soaked environment it is possible to help other professionals hear the clear, important voice of the art. When we are new at a job, it can be tempting to play the game of competing with jargon and spouting information about obscure diagnosis with other mental health practitioners. Our time would probably be better spent encouraging them to make art! I know the desire, though, to be seen as legitimate. I've been the only art therapist in the room and I've babbled my share of trendy terms.

What I have learned is to trust the art. You have a unique blend of knowledge that no one else in the room has. Trust the eloquence and the honesty of the art. Trust that you will move through the blank moments. Trust that the art will say what it needs to say. You might not have to say anything at all. And then go home and make your own art.

References

Asay, T. and Lambert, M. (1999) "The empirical case for the common factors." In M. Hubble, B. Duncan and S. Miller (eds) *The Heart and Soul of Change: What Works in Therapy.* Washington DC: American Psychological Association.

Bohart, A. and Tallman, K. (1999) *How Clients Make Therapy Work: The Process of Active Self-Healing.* Washington DC: American Psychological Association.

Evetts-Secker, J. (1996) *Mother and Daughter Tales.* New York: Abbeville Press.

Hagood, M. (2000) *The Use of Art in Counselling Child and Adult Survivors of Sexual Abuse.* London and Philadelphia: Jessica Kingsley Publishers.

Homrich, A. and Horne, A (2000) "Brief family therapy." In A. Horne *Family Counseling and Therapy.* Itasca: Peacock Publishers.

Hubble, M., Duncan, B. and Miller, S. (eds) (1999) *The Heart and Soul of Change: What Works in Therapy.* Washington DC: American Psychological Association.

Liebmann, M. (1986) *Art Therapy for Groups: A Handbook of Themes, Games and Exercises.* Cambridge: Brookline Books.

McGoldrick, M. and Gerson, R. (1985) *The Genogram in Family Assessment.* York and London: W.W. Norton & Company.

McNiff, S. (1992) *Art as Medicine: Creating a Therapy of the Imagination.* Boston and London: Shambhala.

Moon, B. (2003) *Essentials of Art Therapy Education and Practice.* Springfield: Charles C. Thomas.

Moon, C. (2002) *Studio Art Therapy: Cultivating the Artist Identity in the Art Therapist.* London and Philadelphia: Jessica Kingsley Publishers.

Murphy, J. (1999) "School-based change." In M. Hubble, B. Duncan and S. Miller (eds) *The Heart and Soul of Change: What Works in Therapy.* Washington DC: American Psychological Association.

Ringgold, F., Freeman, L. and Roucher, N. (1996) *Talking to Faith Ringgold.* New York: Crown Publishers.

Riley, S. (1994) *Integrative Approaches to Family Art Therapy.* Chicago: Magnolia Street Publishers.

Rosenbloom, D., Pratt, A. and Pearlman, L. (1999) "Helper's responses to trauma work: understanding and intervening in an organization." In B. Stamm (ed) *Secondary Traumatic Stress: Self-Care Issues for Clinicians.* Lutherville: Sidran Press.

Satir, V. and Baldwin, M. (1983) *Satir Step by Step: A Guide to Creating Change in Families.* Palo Alto: Science and Behavior Books.

Terzian, A. (1993) *The Kids' Multicultural Art Book: Art & Craft Experiences From Around the World.* Charlotte: Williamson Publishing.

Index